T0278126

CASTLES OF KENT

THROUGH TIME

John Guy

AMBERLEY

First published 2023

Amberley Publishing
The Hill, Stroud, Gloucestershire, GL5 4EP
www.amberley-books.com

Copyright © John Guy, 2023

The right of John Guy to be identified as the
Author of this work has been asserted in accordance with
the Copyrights, Designs and Patents Act 1988.

ISBN 978 1 3981 1087 8 (print)
ISBN 978 1 3981 1088 5 (ebook)

All rights reserved. No part of this book may be
reprinted or reproduced or utilised in any form or by
any electronic, mechanical or other means, now known
or hereafter invented, including photocopying and
recording, or in any information storage or retrieval
system, without the permission in writing from the
Publishers.

British Library Cataloguing in Publication Data.
A catalogue record for this book is available from the
British Library.

Typesetting by SJmagic DESIGN SERVICES, India.
Printed in Great Britain.

Introduction

Kent possesses one of the finest collections of castles anywhere in Britain, numbering over sixty in all, including the scanty ruins and earthwork remains of now vanished castles, as well as the more celebrated castles, such as Leeds, Rochester and Dover. It is often assumed that castles belong exclusively to a bygone era and that therefore their histories have ended, but they live on. The story of castles does not end at the last battles to be fought at their gates; it continues into the present day.

Many castles are now ruined, when once they were homes and fortresses. Others, like Allington, have been transformed from ruins back into habitable and very comfortable homes once more. A few, like Dover, can boast a continuous military use right across the centuries from the Iron Age through to the Second World War. Just a few, like Westenhanger, which until recently was a completely overgrown ruin, have since been rescued and beautifully restored and put to an entirely new use – in Westenhanger's case, as a prestigious wedding venue.

Castles, far from being static elements of the historic landscape are, in fact, ever changing, as I hope will be shown in this book. Because of their picturesque and dramatic appearance, castles have often been the subject of antique prints, postcards and early photographs, many of which are reproduced here, enabling us to glimpse their changing fortunes.

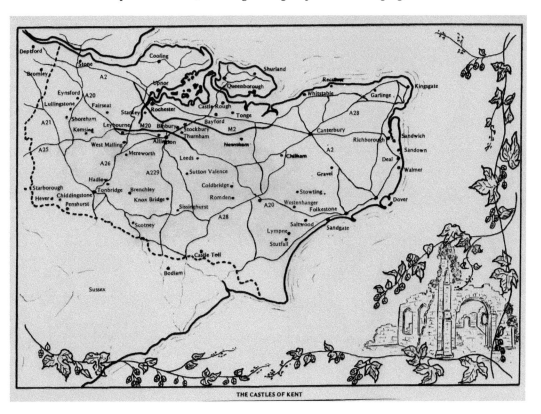

THE CASTLES OF KENT

Forty years ago I wrote the first definitive study of Kent Castles, in a book that has been long out of print. I wanted to bring their histories right up to date and it has surprised me, in visiting each of them again, just how many changes they have seen in the intervening years. For example, although the tourist industry has grown immensely in the last forty years, there are actually fewer castles open, or accessible to the public, now than there were then.

Some have closed their doors to the public and become private homes again, such as Allington. Others, like Lympne, are now only accessible as wedding venues. Castles, such as Leeds and Hever, have remained open, but have greatly diversified, now offering self-catering or bed and breakfast accommodation in some of their outbuildings.

There are other, less obvious changes that have taken place at castles. When looking round castle ruins today it is often assumed that they were cold, draughty and inconvenient places to live, or that those castles still lived in are only grand and comfortable now because of modern-day additions; but neither of these perceptions is true. Even the smallest castle of a minor baron was most likely the grandest building in its locality and, apart from the neighbouring church, was likely also to be the only building constructed of stone in the area.

Even a stone keep, such as Rochester, so often described as being cold and uncomfortable, would have been very much different in its heyday. These two drawings show the keep as it appears today and an exploded view of how it might have been.

Internally, the walls of most castles were plastered with limewash and decorated. Tapestries were hung from the walls and rush mats placed on the floor, all to provide decoration and warmth. Also, contrary to popular belief, most castles would have had some form of windows and most would have had shutters. In their current state of ruination, all

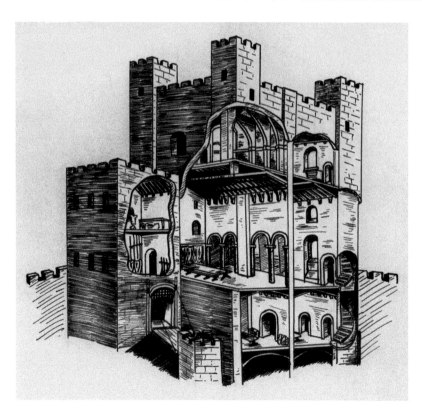

of the timber and internal fittings of castles have been removed, leaving gaping holes where once there were windows. In the Middle Ages glass was still an expensive commodity, so only the wealthiest noblemen could afford to glaze their windows. But many did, in similar style to the lead-light windows we still see in churches. Sometimes, glass was mounted in removable frames so that it could be removed for safekeeping in times of trouble.

If a baron couldn't afford to put glass into his castle's window openings, there were several alternative options. One of these was to grind cow horns or hoofs into a powder, which was then mixed with water and glue to form a paste, which could then be pressed into small panes, very similar to the yellow glass sometimes seen in churches, and then mounted into lead lights. A cheaper option still was to stretch linen over a wooden frame, similar to an artist's canvas, which was then mounted into the window opening.

Both of these options were much cheaper than glass and allowed a translucent light in, not clear enough to look through perhaps, but sufficient to allow light in and keep the weather out, so we should be cautious in making assumptions about what we see today at castles. The same may be said for furnishings. It is human nature to make our houses as warm and comfortable as possible and it may be that castle interiors were actually closer to what we see at furnished castles today, such as Leeds and Hever, than we might hitherto imagined.

These are just a few examples of how we might wish to reinterpret our preconceived notions about life in a castle. I hope that through this collection of comparative views featuring old prints and photographs alongside modern photographs taken from similar viewpoints, it might cast a little more light on the changing nature of our castles and hopefully also capture just a little more of their grandeur than might hitherto have been expected.

A Note on the Illustrations

Most of the illustrations used in this book are taken from my own collection of antique prints and photographs. Sadly, several castles were never drawn or photographed before they were demolished or became ruinous, so it has not been possible to illustrate all of Kent's castles, but I hope this representative collection will give a flavour and good cross-section of what can still be seen. It has not always been possible to choose the exact viewpoint used in some of the old prints because of changes in the landscape, but I have chosen viewpoints that illustrate the point in question. I have, for similar reasons, used aerial photographs for the modern views because they allow us to see past the modern clutter that can sometimes get in the way of a good photo!

In presenting the images in this book, two images are shown on each page, one old and one new. The older image is always on the top, which alleviates the need to constantly refer to statements like 'the old' or 'the modern'. Similarly, not all of the dates are known for the old views, which I have given where they are known to me. But, as a general rule of thumb, all of the old prints are taken from original drawings and engravings that date mostly from the mid-eighteenth to the mid-nineteenth centuries. Very few illustrations exist from before that time, but the reader should hopefully get a feel for how our castles looked between 100 and 200 years ago. Similarly, the postcard views and old photographs date mostly from the 1920s to 1940s and the contrast between these and modern views is quite striking.

This book is primarily an illustrated work to show the changing appearance of our castles and is not intended to be a detailed history book. The captions are intended simply to highlight these changes.

Allington Castle

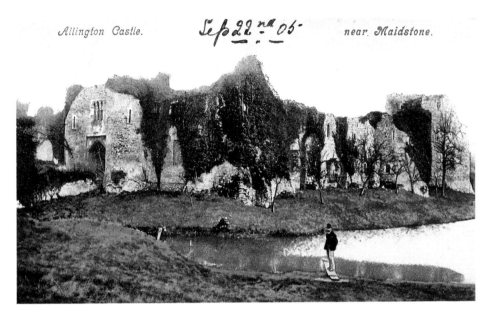

Allington Castle. *Sep 22nd 05.* *near Maidstone.*

The first castle at Allington was built soon after the Norman Conquest. It was of the motte and bailey type and stood just south of the present castle. This was replaced in 1282 by a stone castle by Stephen de Penchester, much of which still survives. By the early 1800s, the castle had become ruinous, with a farmhouse built into the gatehouse. The castle today reflects the beautiful restoration by Lord Conway after he bought the castle in 1905. The top view shows the castle just after he purchased it. He spent the next thirty years making the castle once more a habitable home.

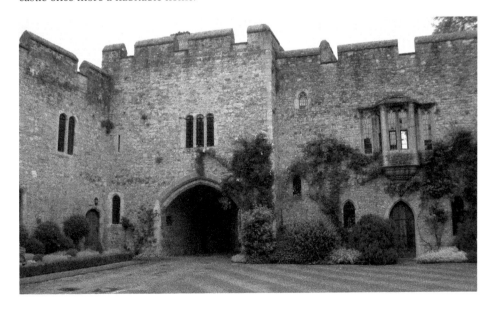

One of the outstanding features of Allington is the fine gatehouse, shown here. The gabled roofs in the old print (c. 1830) replaced the original battlements and several of the adjoining rooms in the courtyard were reduced to use as barns and farm buildings. On Lord Conway's death the castle passed to his daughter and was eventually sold to the Carmelite Order of nearby Aylesford Priory and was opened to the public. More recently it was sold again to Sir Robert Worcester, who carried out further restoration work on the castle, which is once more a private house occasionally open to the public.

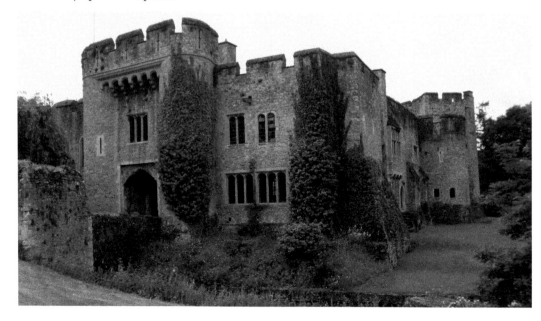

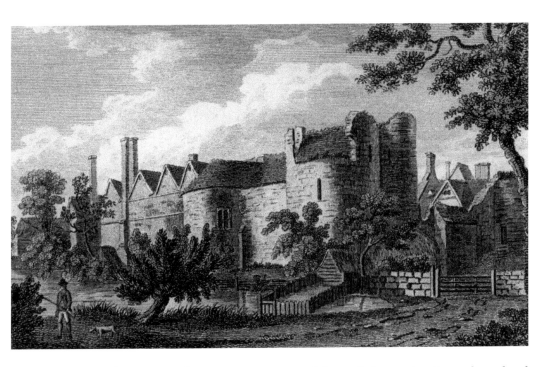

The River Medway was used to create a moat around the castle by constructing a channel and from this elevation the walls of the castle rise sheer to a height of around 40 feet. The gabled roofs to the left of the print (c. 1830) are of the Tudor house that was inserted into the inner court, which still survives. Henry VIII was a frequent visitor to Allington. So fearful of his safety was he that he insisted on being dry-stone walled into his room each night in the tower to the right in the modern view.

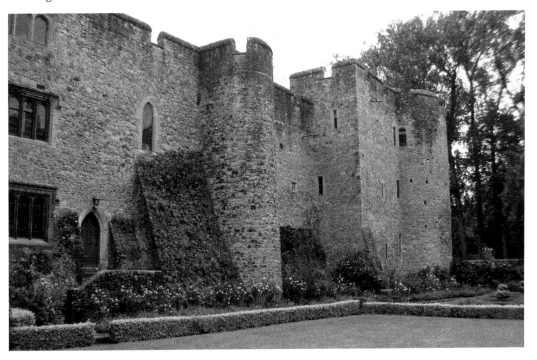

Canterbury Castle

Although Canterbury was furnished with a castle from Norman times, sadly very little of it survives today, marooned almost on the edge of a busy roundabout. Long stretches of the city wall survive, however, which formed almost a huge outer bailey to the castle. The Dane John mound, adjacent to the city wall, is possibly a survival from the first motte and bailey castle. (The name is a corruption of the French word for a keep, the 'donjon', and has nothing to do with the Danes!). The mound was landscaped in 1790 (the date of this print) and is still popular with visitors today.

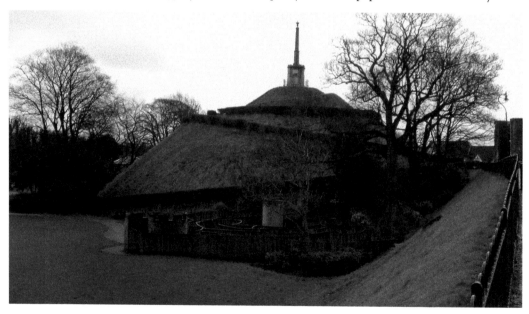

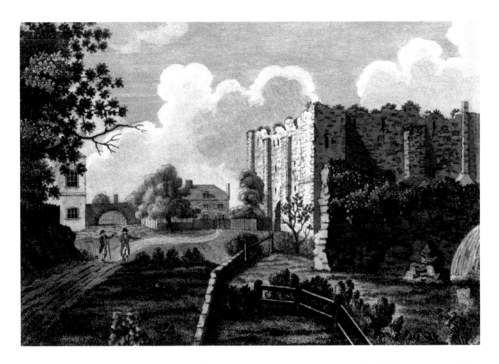

The keep at Canterbury is one of the earliest stone keeps in England, built *c.* 1080. The original castle once covered an area of over 4 acres, but sadly only the keep survives, and that very ruinous. Following the strengthening of the city walls and West Gate in 1370–80 the castle declined in importance and gradually fell out of use. In 1826 the remains of the keep were used as a pumphouse and coal store. It was finally acquired by the City Council in 1928, who rescued what remains of this once impressive building.

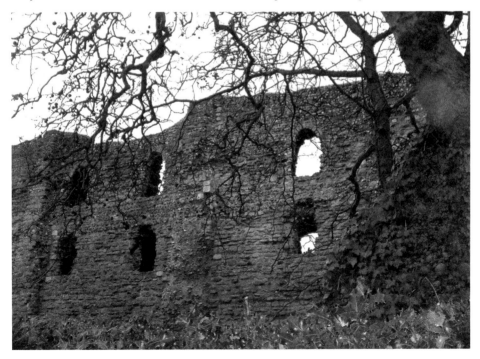

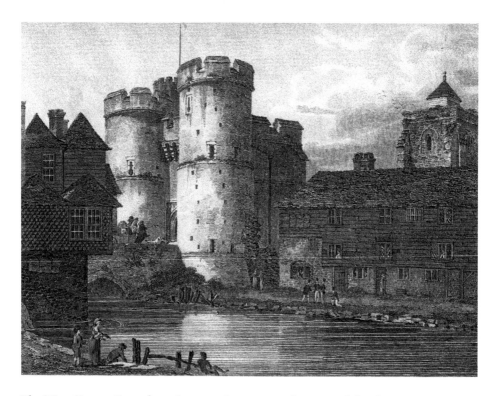

The West Gate at Canterbury is a massive construction, one of the finest town gates in England. It is almost a self-contained fortress in its own right and it soon superseded the castle itself in importance. The picturesque view above dates from *c.* 1830. The gate presents something of a bottleneck to modern traffic and has several times been at risk of demolition, but happily it survives as part of the attractive West Gate Gardens today on the banks of the River Stour.

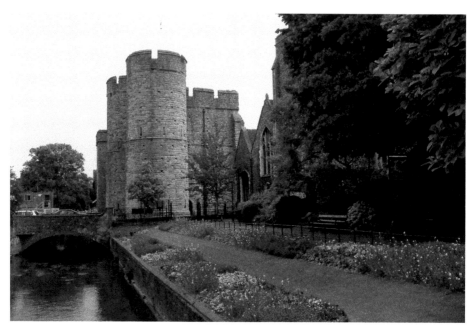

Chiddingstone Castle

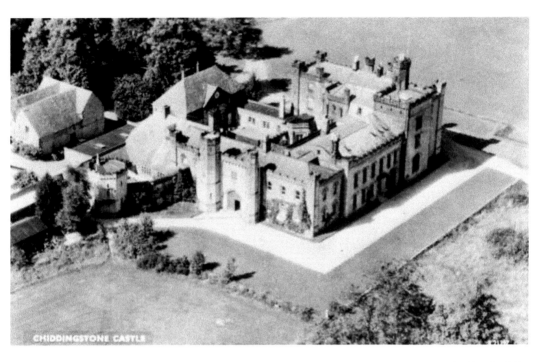

The setting of Chiddingstone Castle is picturesque in the extreme, standing at the head of the main village street in Chiddingstone. It is a sham castle in true 'mock gothic' style, although it stands on the site of a medieval manor house and still preserves part of a sixteenth-century house at its core. This Tudor house was largely torn down in 1679 and replaced with a red-brick Caroline mansion. In 1808 this house was refaced in stone and castellated features added, earning it the title of 'castle'.

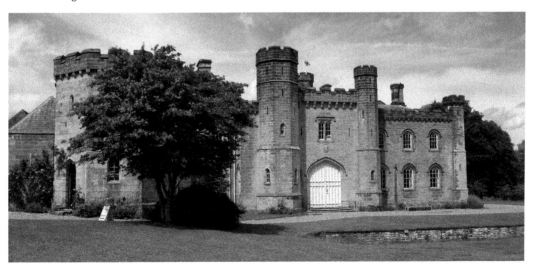

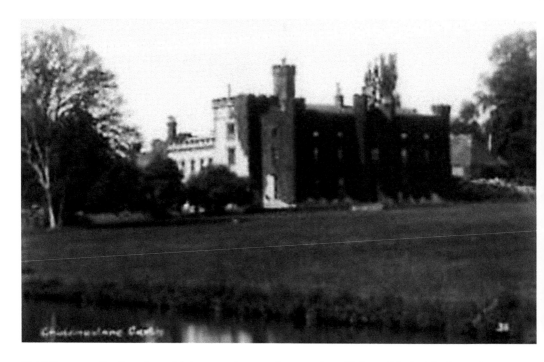

Chiddingstone Castle today, with its attendant gardens, park and lake is delightful. The park can usually be freely accessed at any time. The castle was purchased in 1955 by Denys Eyre Bower and opened to the public the following year. He used the house to display his huge private collections of Japanese, Stuart and Egyptian artefacts and furnishings. Today, it is owned by a Trust and no longer lived in as a house, but it is still open to the public.

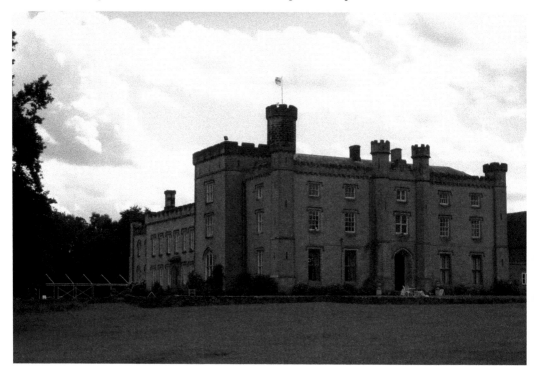

Chilham Castle

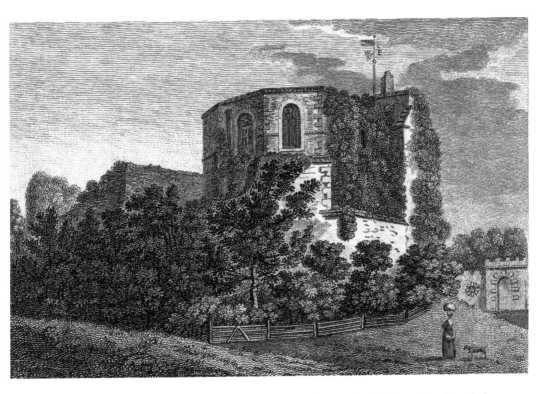

There are two castles to be seen at Chilham, with links to a third. The original castle here was built in the Norman period and was of the motte and bailey type. The first stone castle was begun in 1171. The keep is unusual in being of octagonal design, the only one in Kent. It remains in good condition (minus its battlements), as does the wall of the inner bailey. The remainder of the castle, unfortunately, was demolished in the sixteenth century.

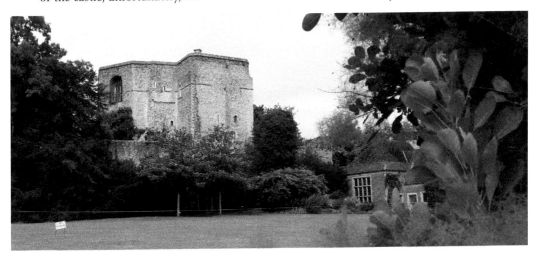

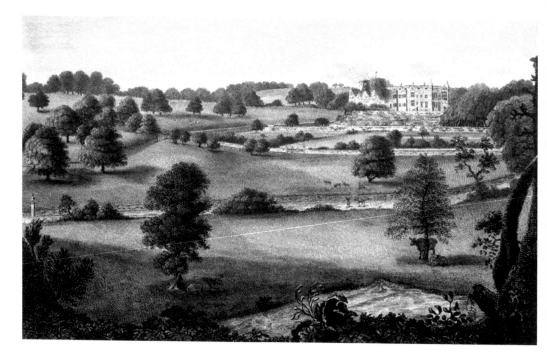

In 1542 Chilham Castle became the property of Sir Thomas Cheney, Warden of the Cinque Ports. It was he who demolished the outer walls of the castle, leaving only the keep and inner bailey. He transported the materials along the River Stour and Wantsum Channel to the Swale, and then on to Eastchurch, on the Isle of Sheppey, where he held another castle. This castle was also demolished and he used the combined materials to construct Shurland Hall (see separate entry).

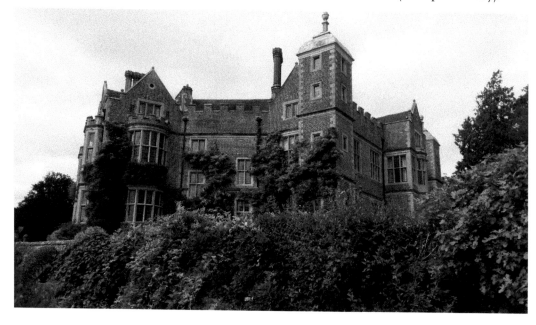

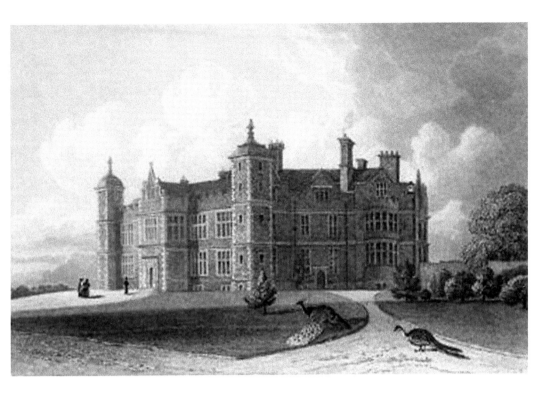

A later descendant of Cheyney, Sir Dudley Digges, later built the second 'castle' at Chilham between 1603 and 1616. Although often referred to as a castle, it is in fact a fine Jacobean mansion. This building and the attached park, lake and gardens, and the original Norman keep are now held by two separate owners. The keep is now a private house and is not open to the public, but the gardens of the Jacobean house are sometimes open during the summer, giving glimpses of both buildings, which stand beside one another.

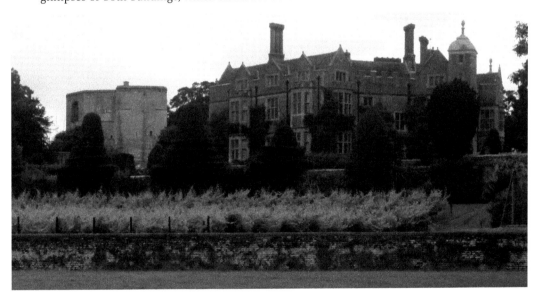

Cooling Castle

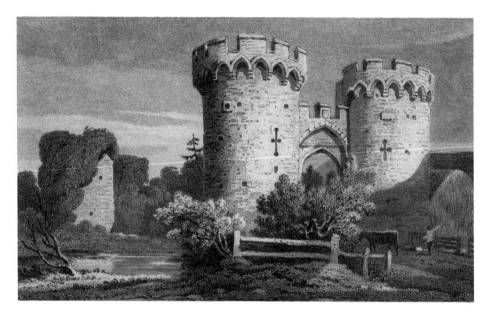

When Cooling Castle was built during the 1380s on the Hoo Peninsula, it stood very close to the sea, but now the Thames Estuary is some 2 miles distant following land reclamation over the succeeding centuries. It consists of two separate wards, surrounded by a figure-of-eight moat. A great deal of the inner ward still survives, though only scanty remains of the outer, which is now under separate ownership. The inner ward now contains a private house, while the barns housed within the outer ward are used for wedding receptions.

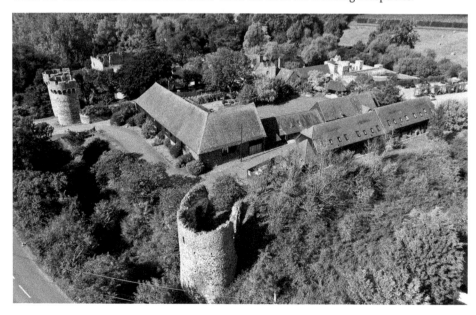

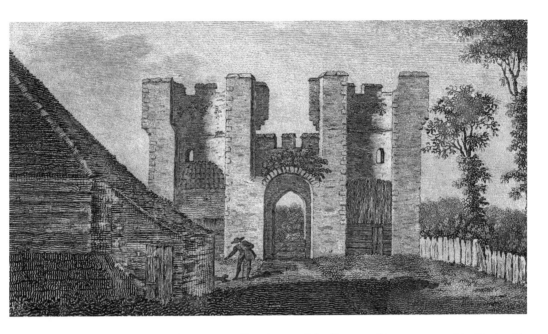

The magnificent outer gatehouse at Cooling is one of the finest and best preserved in Kent, with its twin towers top-heavy with a complete row of machicolations around the parapet. Although this gatehouse is a familiar site to many, it is not generally realised that it is backless and always was so. This was a common practice in the Middle Ages and was for defensive purposes. If attackers were successful in breaching the walls and taking the gatehouse, it could not be used against the defenders because it offered no protection to them.

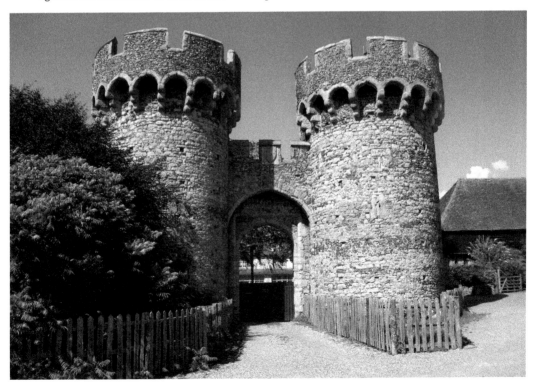

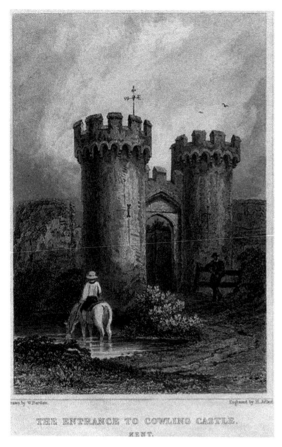

THE ENTRANCE TO COWLING CASTLE.
KENT.

The inner ward at Cooling survives in good condition and almost forms a separate castle in its own right, complete with a second gatehouse, connecting to the outer ward by its own drawbridge. Remains of a hall and chapel, as well as the corner towers survive. The castle is built from Kentish ragstone and flint (sometimes in a chequerboard effect), traditional Kentish materials, and some of the vaulting uses chalk blocks, which are much lighter in weight. Some of the earliest gun-loops in any castle can be seen at Cooling.

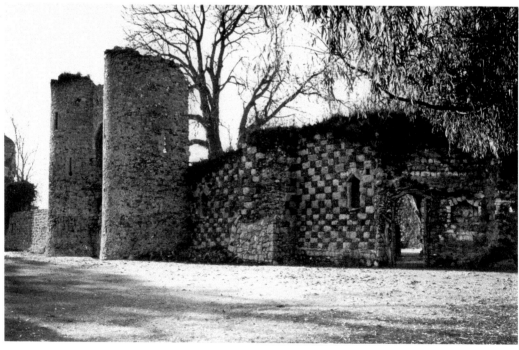

Deal Castle

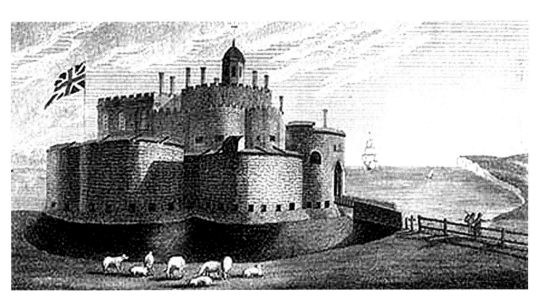

During the Tudor period, before the construction of Chatham Dockyard, the fleet was often put to anchor off the east coast of Kent in the relatively safe waters between the shore and the Goodwin Sands, known as the Downs. From there the fleet could easily put to sea and the Channel if needed. To protect the fleet Henry VIII had three massive castles constructed at Deal, Walmer and Sandown. Unlike medieval castles, they had rounded bastions for the use of heavy cannon. Deal was the largest of these and incorporated many innovative new features.

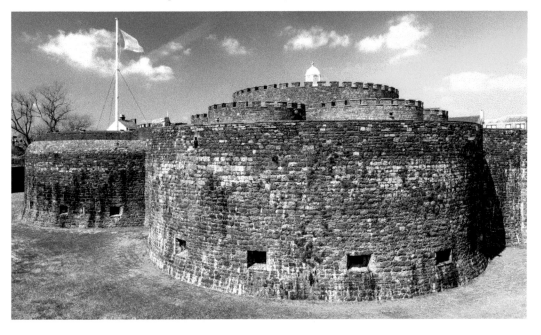

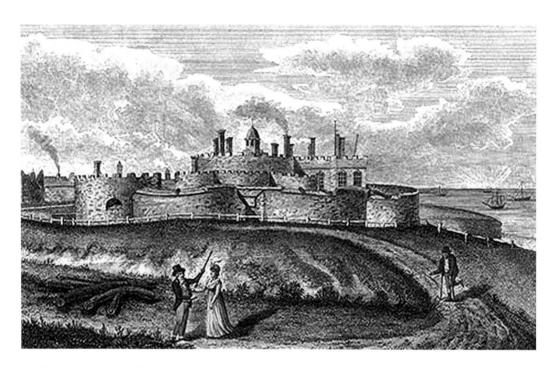

Deal Castle had a sexfoil plan arranged in three tiers of fighting platforms, a central round tower surrounded by six bastions and six lunettes, with a courtyard between. With the changing face of warfare, and the removal of the fleet to safer havens of purpose-built dockyards, the three castles of the Downs became somewhat redundant and were used more as barracks. By the early 1730s (the date of the print above) a residential house for officers was built, somewhat incongruously, on top of several of the bastions. Happily for us today, this was damaged by a bomb in the Second World War and has since been removed to reveal the original structure intact beneath.

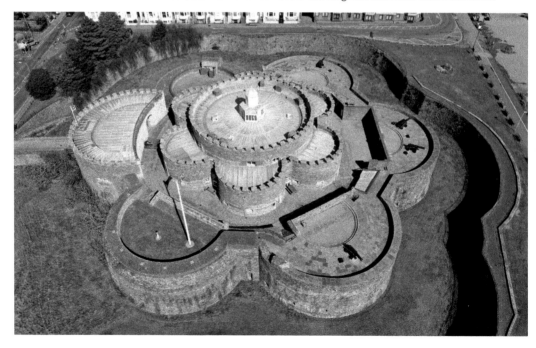

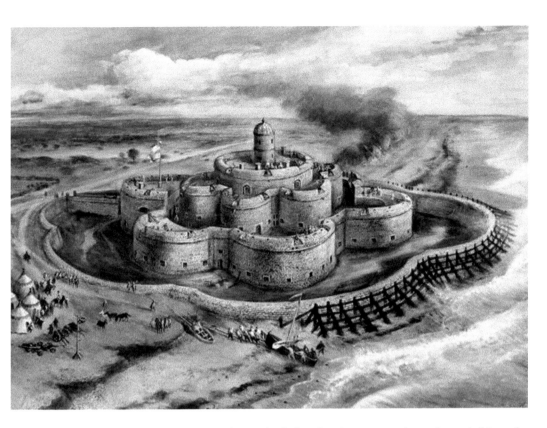

Built away from the main town, as the castle declined in importance it gently settled into the surrounding landscape, as can be seen from this rather pastoral view. From the eighteenth century onwards, the castle was somewhat 'beautified' with the removal of some of the Tudor gun embrasures, to be replaced by imitation medieval-style battlements. Despite this, however, the castle retains many of its original features.

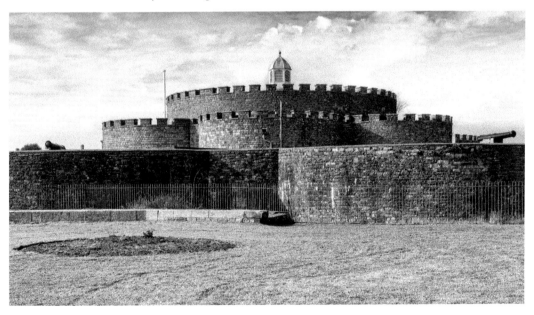

Dover Castle

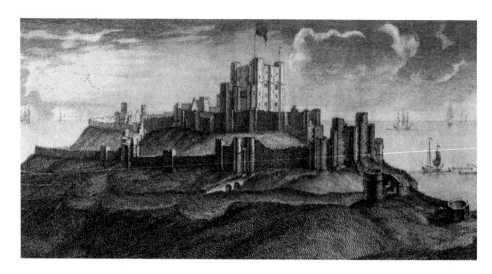

Dover Castle is one of the premier castles in England, displaying continuous occupation and military use from the Iron Age right down to modern times. It was still being used for military purposes throughout the Second World War and the army continued to have a presence there up to the 1960s. The castle crowns the clifftop above the town and encompasses within its walls an Iron Age hill fort, a Roman lighthouse and a Saxon church, as well as the castle itself, and all in splendid condition.

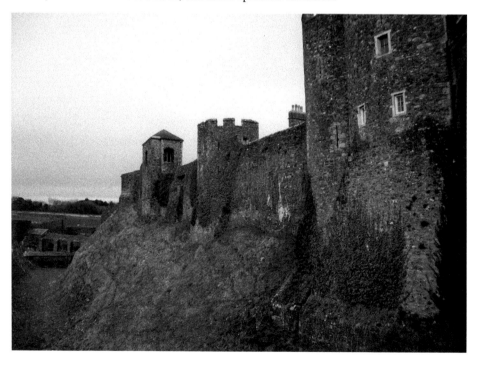

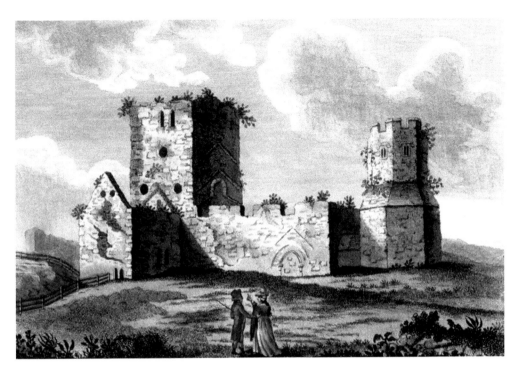

The Saxon church of St Mary in Castro and the Roman lighthouse (the Pharos) stand within the earthwork remains of the Iron Age hill fort. As can be seen from this eighteenth-century print, the church of St Mary had by that time fallen into disrepair. Interestingly, it was attached to the Roman lighthouse, which served as a bell tower. The church was restored in the nineteenth century, but it still preserves many Saxon features. There was also a Saxon burgh, or township, on the site of what is now the inner bailey.

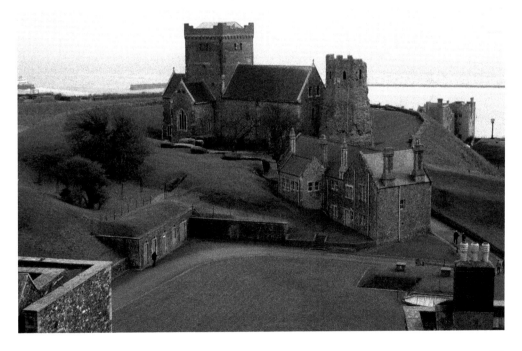

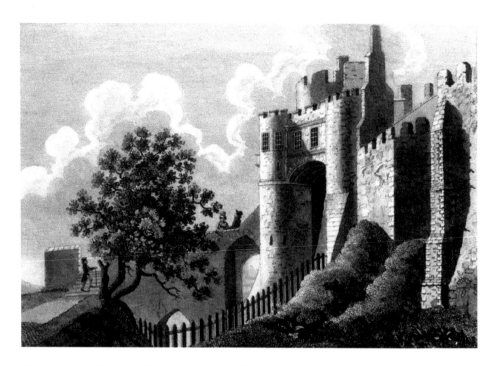

The outer gatehouse at Dover is a magnificent structure, of somewhat unusual design. Known as the Constable's Gate, it is most impressive when seen from the outward approach, clinging to the side of the enormously deep ditch that surrounds the castle. It still serves as one of the official residences of the Lord Warden of the Cinque Ports. It was built between 1217 and 1256 to provide a stronger and more formidable entrance to the castle.

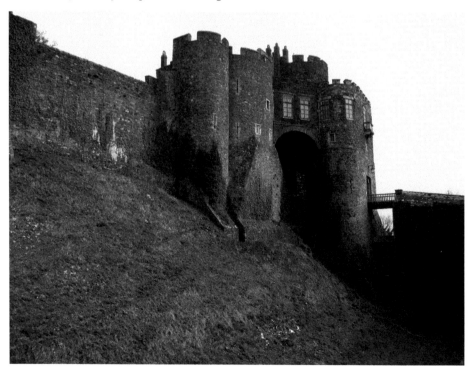

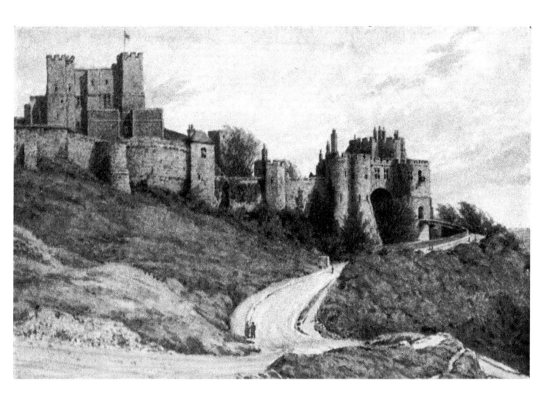

Both the old and new views depicted here show perfectly the multiple lines of defences that Dover Castle possesses, one of the first examples of concentric design in the country. At the centre stands the magnificent keep, one of the finest in Europe. It has many special features, including a piped water system. It was begun by Henry II in 1180. Many of the walls and towers of the outer and inner curtain walls were reduced in height during the Napoleonic period to carry heavy guns, and beneath the castle are extensive medieval, Napoleonic and later tunnels, a hidden part of the overall defence system.

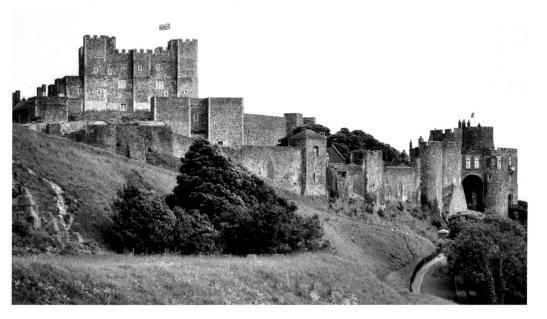

Eynsford Castle

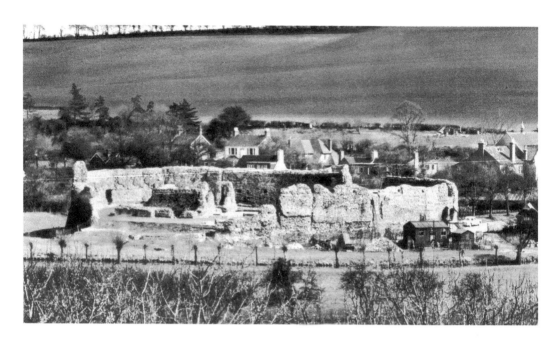

The castle at Eynsford has a unique and complex history. It stands on the site of a hall and a watchtower. The curtain wall we see today is one of the earliest in Britain, first constructed in around 1100 and still stands to a height of over 20 feet. It encloses an oval courtyard, but is actually polygonal in shape, made up of short stretches of straight wall. There are the remains of a hall and domestic buildings within the enclosure. The outer wall revets a mound so that the ground level inside is higher than that outside. The old views here are taken from postcards dated *c.* 1930.

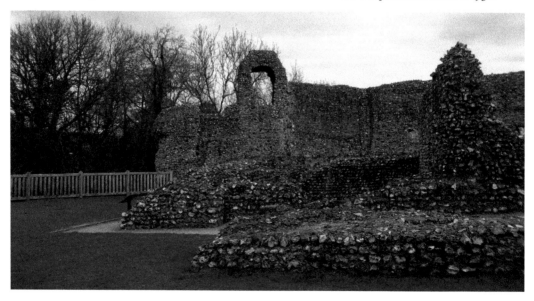

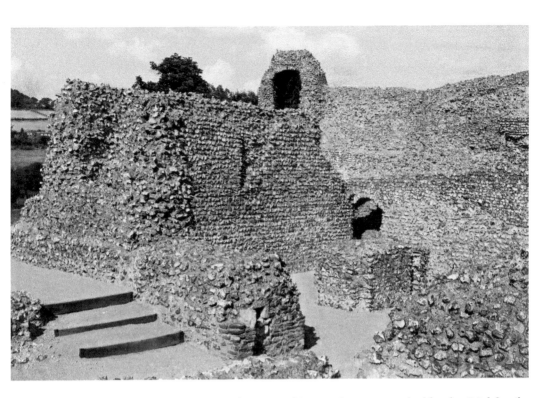

Ownership of the castle was often in dispute and in 1312 it was ransacked by the Criol family. A great deal of damage was done to the castle, which was repaired but the dispute remained unsettled. It was afterwards used as a manorial court for a while, but the castle was never lived in again, unusual for such an early date, which possibly explains why there are no later additions such as towers or a gatehouse. It does, however, give us a unique insight into how early Norman castles might have looked. For a short while in the eighteenth century it was used to house dog kennels. Given that the castle was abandoned so early, it is remarkable that so much of it has survived, and in such good condition.

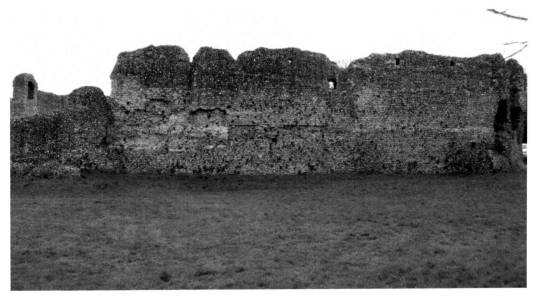

Garlinge Castle

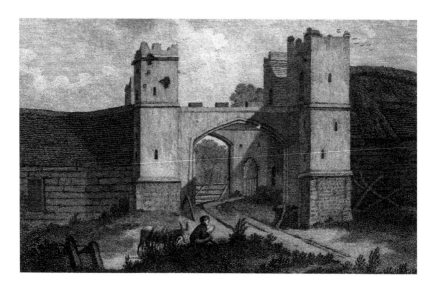

In 1435 England's Flemish allies turned against us and there followed a wave of re-fortification in preparation for an attack, particularly in the vulnerable south-east. In response to the threat, John Dent-de-Lion (Dandelion) fortified his manor at Garlinge, near Margate, in 1440. When the threat of invasion subsided, the castle reverted to its use as a manor house – and the various nefarious smuggling activities for which Dent-de-Lion was famous. During the eighteenth century many alterations were made, transforming what was a relatively modest house into a vast mansion, as Margate grew in popularity as a fashionable resort.

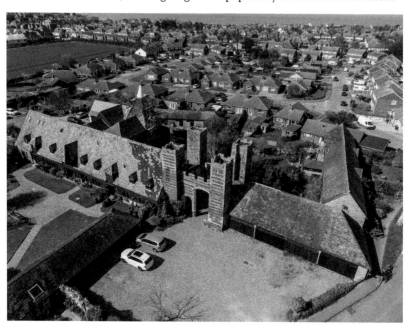

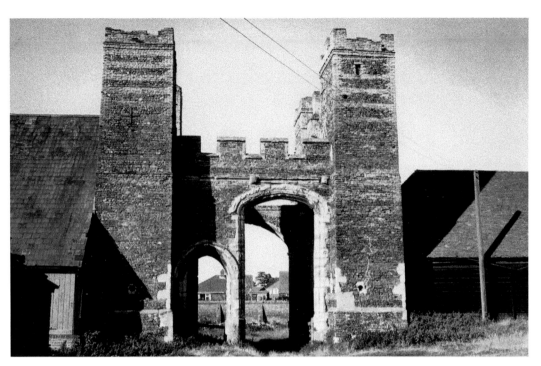

Sometime in the nineteenth century almost the entire house was demolished and its materials used in the surrounding area. The gatehouse was retained, but the estate reverted to its former use as a farm, as shown here. The gatehouse is something of a surprise in this quiet corner of Margate, built from alternating courses of brick and flint to create a wasp-like effect. The gatehouse and adjacent buildings still survive, but almost the entire site of the 'castle' is now covered in modern housing, leaving these once magnificent buildings standing forlornly in a somewhat incongruous setting. Some of the internal fittings were later incorporated into houses in the area.

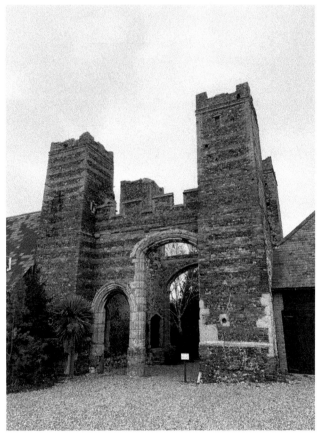

Hadlow Castle

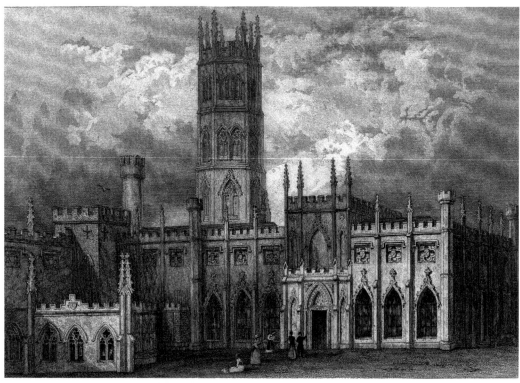

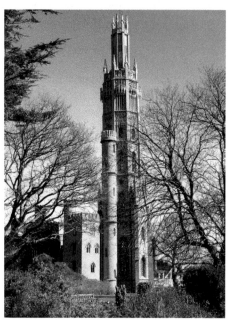

There is no record of a medieval castle ever having existed at Hadlow, the current building taking its name from the Gothicised mansion erected there in the 1830s by Walter Barton May. The print above shows the 'castle' soon after it was built. The splendid octagonal tower, soaring 170 feet into the air, was added between 1838 and 1840. A very flamboyant building, sadly much of the 'castle' has been demolished, except for the tower, entrance lodges (which can be seen from the High Street) and a stable block. It was built from brick and covered in cement to resemble stone. The tower has recently undergone an extensive restoration and now offers a somewhat quirky short-term holiday let.

Hever Castle

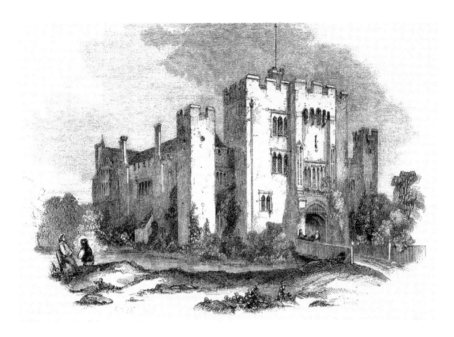

The three old views of Hever Castle shown here (dating from the mid to late nineteenth century) are, on the face of it, remarkably similar. However, with a castle such as Hever that has been more or less in continuous habitation, the external changes are more subtle. The castle was built on the site of a former manor house in 1340. It was modified and the fortifications strengthened in 1380 by Sir John de Cobham, who also owned and built his other castle, Cooling, at around the same time. Although small in stature, Hever should still be regarded as a true castle and capable of a stout resistance if need be.

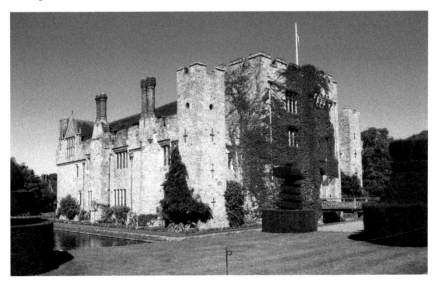

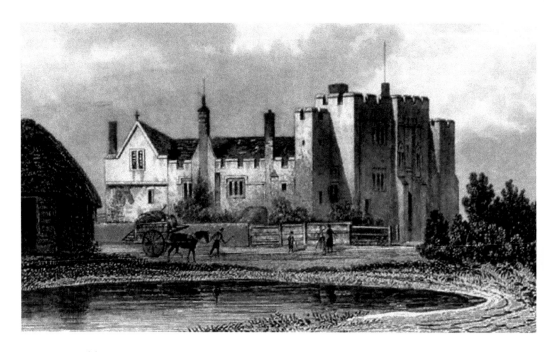

Hever was sold in 1462 to Sir Geoffrey Bullen, of Norfolk. He had been appointed Lord Mayor of London in 1459 and it is thought that he bought the castle to be within easy reach of the capital. It was he who converted the interior of the castle into the splendid Tudor country house we see today. His grandson, Sir Thomas Bullen (Boleyn), was the father of Anne Boleyn, and it was at Hever that Henry VIII, who was a frequent visitor to the castle, first met Anne, a meeting that was to change the course of history.

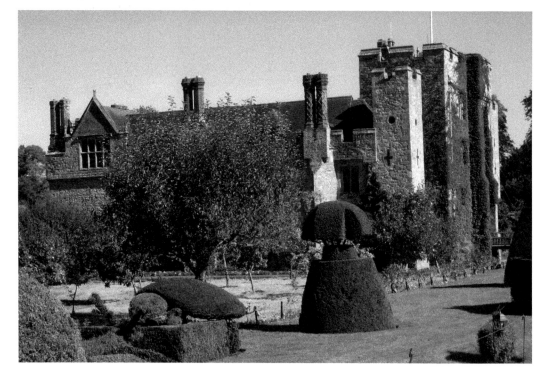

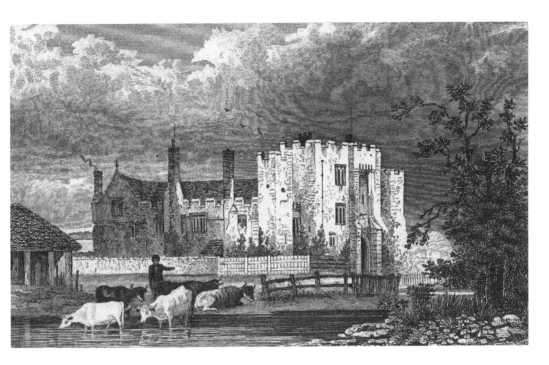

Despite its grand associations with royalty, Hever suffered, like so many other castles, of neglect in later years and became demoted to the humble role of farmhouse. The castle never became a total ruin, although it was neglected and was rescued from that fate by William Waldorf Astor in 1903, an American who became a naturalised British subject. It was he who also created the magnificent Italianate gardens and built the mock-Tudor village alongside, rather than extend the castle itself, a decision for which he must be applauded. It is now possible to stay at the castle in this 'village' (which is actually a single building internally) for short stays.

Kingsgate Castle

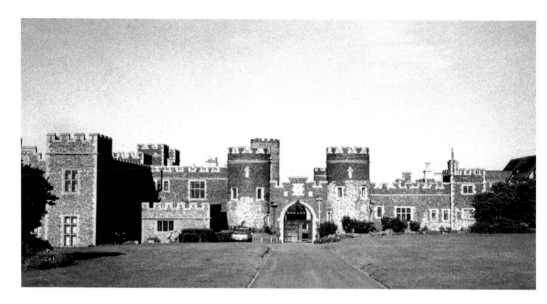

Although Kingsgate Castle looks every bit an authentic medieval castle at first glance, it is in fact a sham castle, built originally in the late eighteenth century by Lord Holland. Originally known as Holland House, it was almost completely rebuilt in the 1860s to create the 'castle' we see today. It was often the subject of postcards, as seen here in this view dated 1930. The castle still survives intact as originally conceived, although the interior has been divided into a number of residential apartments.

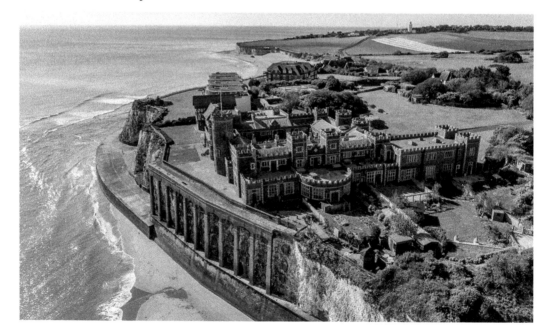

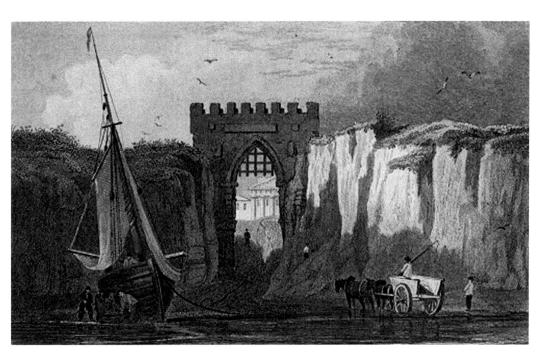

The castle at Kingsgate still looks very impressive on its clifftop setting between Margate and Broadstairs, overlooking a beautiful sandy bay. Lord Holland surrounded his original house with a number of follies, equally authentic looking. One of these was a replica of a Henry VIII-style castle, which was built as a ruin and still survives today a little further along the clifftop. A defensive arch and gate of medieval date once protected the settlement of Kingsgate from the seaward approach. This has now gone, but a similar arch survives at nearby Broadstairs.

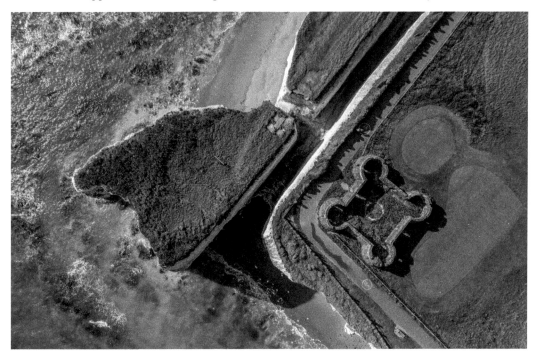

Leeds Castle

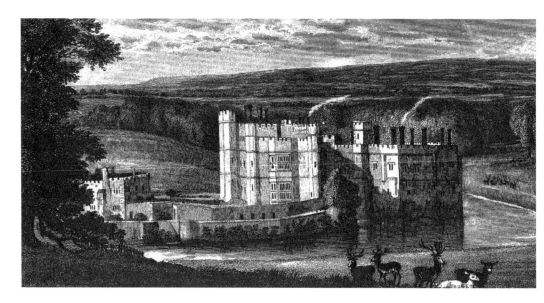

Leeds Castle is famed worldwide as being the 'loveliest castle in the world', a mantle justly deserved perhaps considering its beautiful and romantic setting on two islands in the middle of a lake. The castle has a long pedigree and has been in almost continuous occupation since it was first built. A wooden fortification of sorts was constructed on the larger island in the River Len as long ago as 857, by Led (from whom the castle takes its name) who was the chief minister of Ethelbert IV, King of Kent – although this first structure was probably a hall surrounded by a palisade rather than a castle proper.

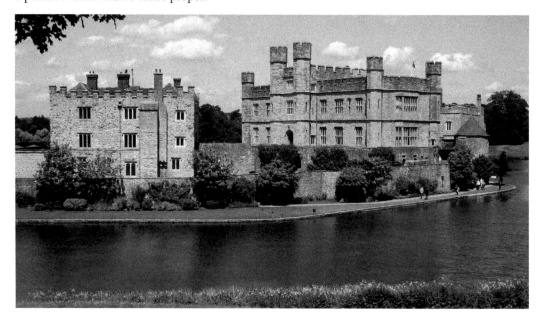

The first stone castle at Leeds was built in 1119 by Robert de Crevecoeur. Henry III forced the family to hand the castle to Roger de Leyburn, whose son handed it to Edward I in 1272. Leeds became a great favourite of Edward and his queen, Eleanor, thus beginning a long tradition of the castle being associated with the queens of England. A great many improvements were made at that time, including adding a second bailey, extending the lake and adding concentric lines of curtain wall.

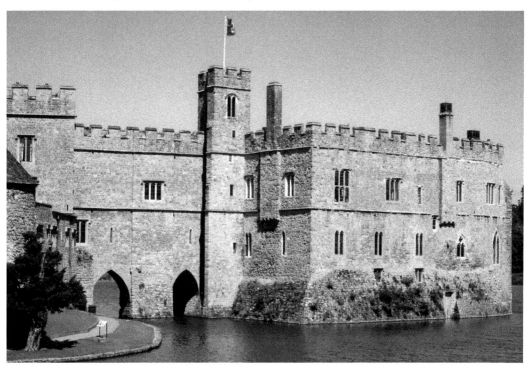

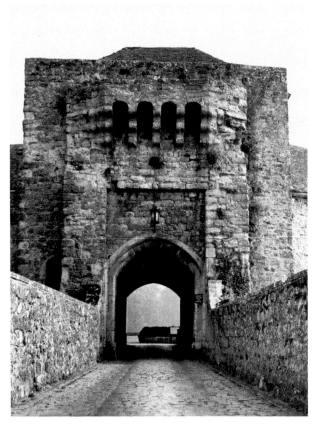

Edward I retained the original Norman entrance gatehouse and shell keep, built on the second, smaller island. The keep is now known as the Gloriette, and Edward added an extra storey to create more apartments. The castle became a great royal favourite, including Henry VIII, who added the Maiden's Tower. There have been many alterations to the castle, but the basic original structure still remains. Stuart and Georgian additions were made, but these were swept away in 1822 to create the mock-Tudor block that now dominates the main island. Latterly, the castle was owned by Lady Baillie (an Anglo-American) who spent a lot of money on preserving the castle and creating the beautiful gardens. It is now run by a Trust and it is possible to stay in the Maiden's Tower and other buildings as short-term holiday lets.

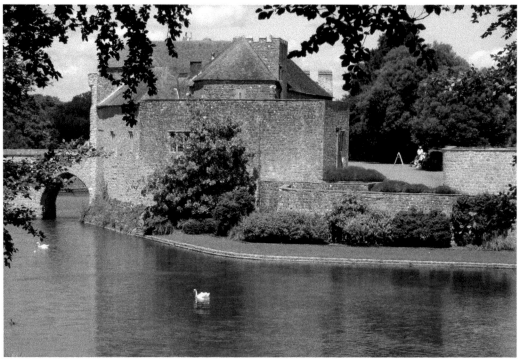

Leybourne Castle

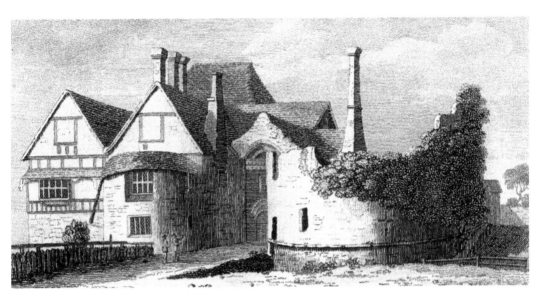

Leybourne is another of those castles in Kent that comes as something of a surprise, tucked away as it is amidst the urban sprawl near Maidstone. Leybourne began life as a motte and bailey castle. It was replaced in stone around 1190, although the present remains date mostly from the thirteenth and fourteenth centuries. As the castle fell out of use, a farmhouse was incorporated into the ruins (*c.* 1737), as seen in the print. This burnt down and was replaced by the present house in 1930, built between the gatehouse and a ruined tower to the south, in sympathy with the ruins rather than trying to imitate medieval styles.

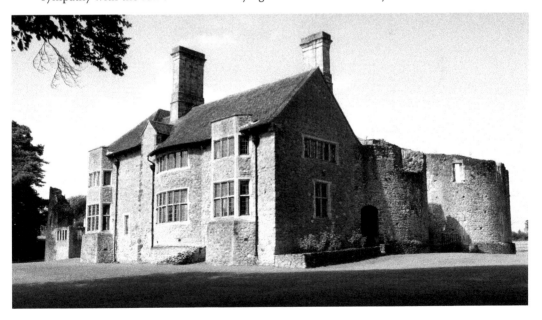

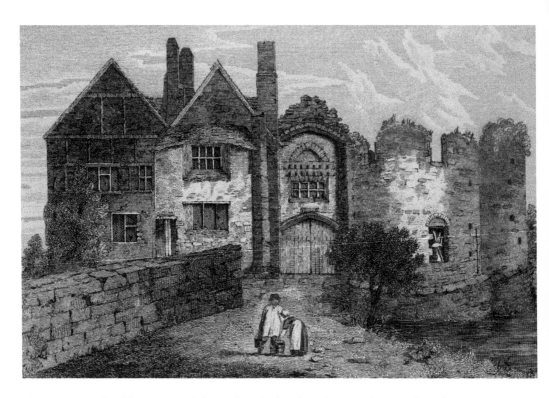

There are considerable remains of the castle, which although privately owned can be seen from the neighbouring churchyard. Its most unusual features can be seen in the gatehouse. The portcullis here ran in grooves on the outside of the wall rather than being contained within the gatehouse, as is usual. Another unusual feature is the chute above the gateway, which allowed any fires at the gate to be extinguished or missiles dropped onto attackers seeking entry to the castle.

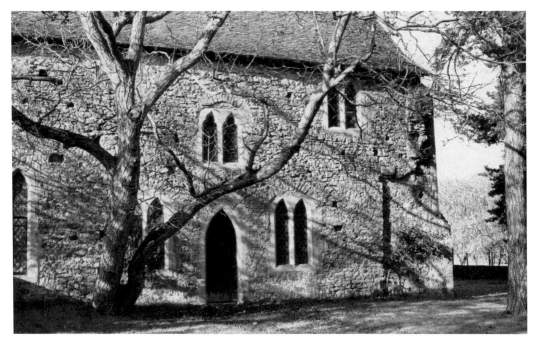

Lullingstone Castle

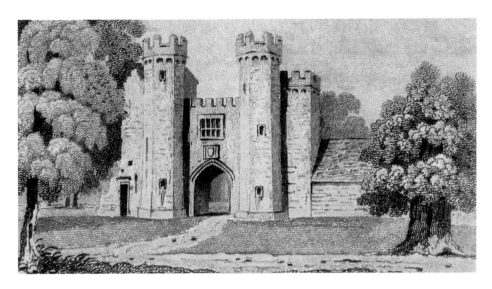

The original Lullingstone was located around a mile down the road, at Shoreham. Sir John Peche built a fine mansion at Lullingstone, with two magnificent brick, castellated gatehouses in front of an earlier Tudor house, known as Lullingstone Park. One of these was pulled down by a later descendant, John Dyke. The other survives as a splendid example of Tudor architecture in the medieval style. The earlier view dates from around 1820. Curiously, the church of St Botolph on the castle lawn is not a private chapel by the parish church.

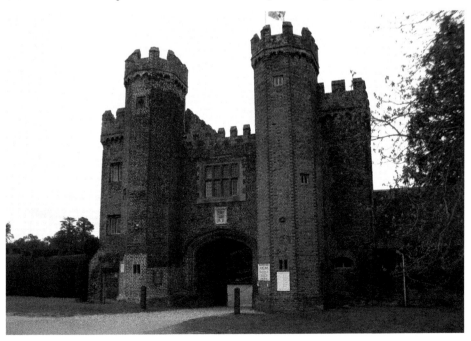

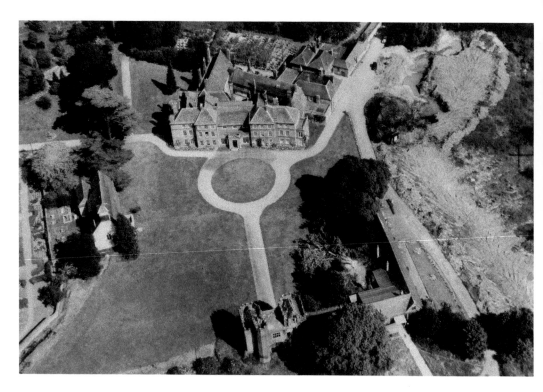

Looking through the gatehouse arch can be seen a fine Queen Anne-style house. In fact, it is only a façade and dates from *c.* 1740. Behind it still stands the original Tudor house at its core. The Hart family transferred the title of 'castle' to their house at Lullingstone in 1738, purely for prestigious reasons. From that point on the original Lullingstone Castle came to be known as Castle Farm, Shoreham, the scanty remains of which have been incorporated into a farmhouse.

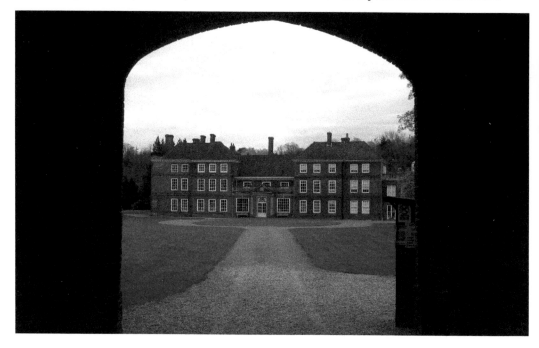

Lympne Castle

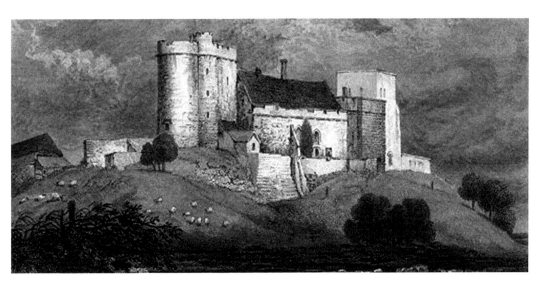

There is a lot of history to be seen at Lympne. A Roman fort (known as Stutfall Castle – see separate entry) occupied the lower slopes of the hill upon which the present castle stands, overlooking a harbour before the sea retreated some 2 miles. The castle itself stands on the site of a Roman watchtower and the village of Lympne occupies the site of a small Roman settlement. The manor of Lympne came under the possession of the Archdeacons of Canterbury, who built the original castle in Norman times.

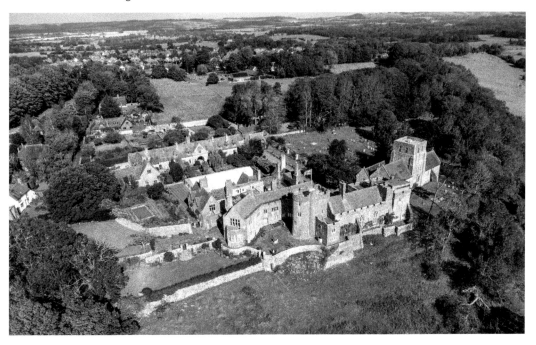

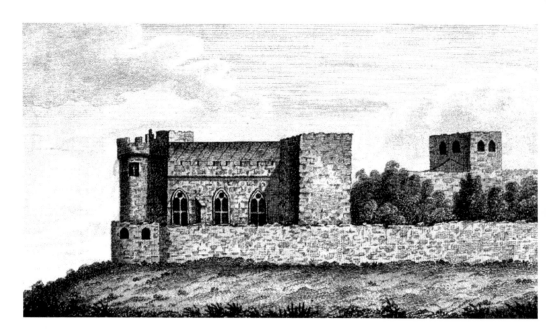

The earlier castle at Lympne was rebuilt around 1360 by the Archdeacons because of the site's strategic importance in the wars with France. The castle consists principally of two towers, with a hall range between and a courtyard beyond. By the nineteenth century the castle had been converted into farm buildings. In 1905 it was acquired by a Mr Tennent, who had the Edwardian mansion built adjacent to the great hall. It later passed through several private owners and is now used as a very prestigious wedding venue.

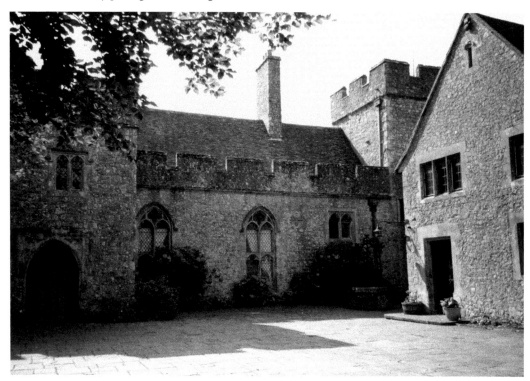

Mereworth Castle

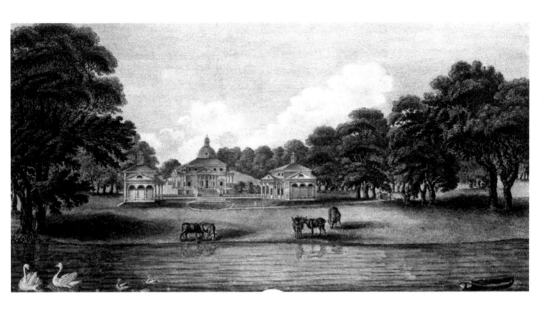

The current building calling itself Mereworth Castle is a Palladian-style villa built in 1723 by Colin Campbell for the 7th Earl of Westmorland. It stands on the site of a medieval fortified manor house of the same name. No trace of the original castle, or indeed village of Mereworth, remains now as the Earl had them demolished and re-sited the village some distance away so as not to interrupt the view from his new 'castle'. The house can only be glimpsed from the road today. However, on a lane close to the remote church at East Peckham can be seen the ruined entrance lodge to the park, shown here, which has not faired so well as the house.

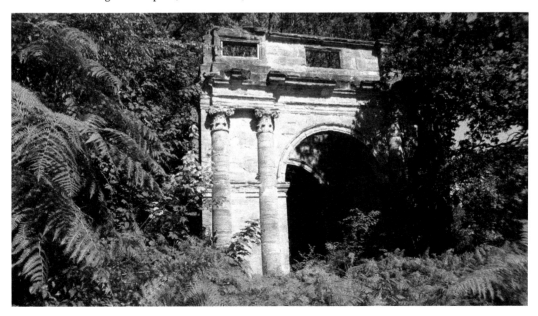

Penshurst Place

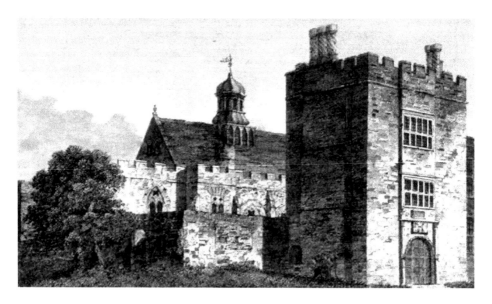

Penshurst Place began life as a medieval manor house that, in 1392, was converted into a castle following a licence to crenelate (fortify) in response to the threat of invasion from the Continent. Then, in more peaceful times, it was converted back into a house by knocking down several of the curtain walls between the towers, some of which still survive later alterations to the house. It was a simple, courtyard castle with square towers at each corner and another midway along one of the walls which served as a gatehouse, which is still its function today.

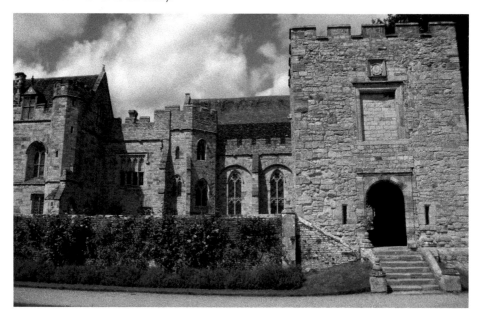

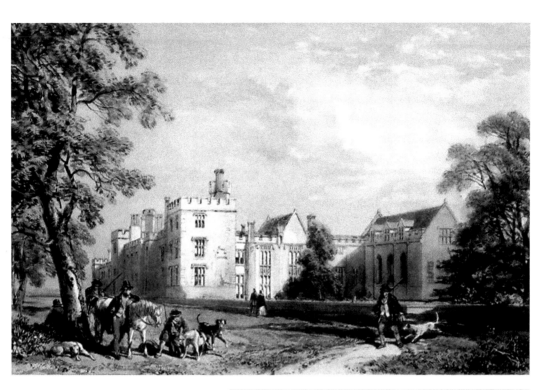

Usually, when a castle's military use had been superseded, they were either knocked down and a house built on the site, or a separate house was built elsewhere on the estate and the castle was left to moulder as a ruin or be converted to a farmhouse. At Penshurst, a different story unfolded and most of the original domestic buildings of the castle were retained. What we see here is one of the finest collections of medieval domestic apartments to be seen anywhere in Europe. All castles would once have been provisioned with such buildings within their curtain walls, but at Penshurst they survive, including the magnificent great hall, giving us a unique insight into life in a castle and the comforts afforded by them, an aspect often misunderstood.

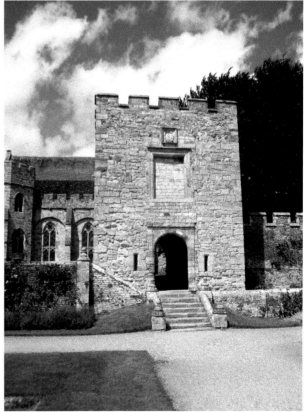

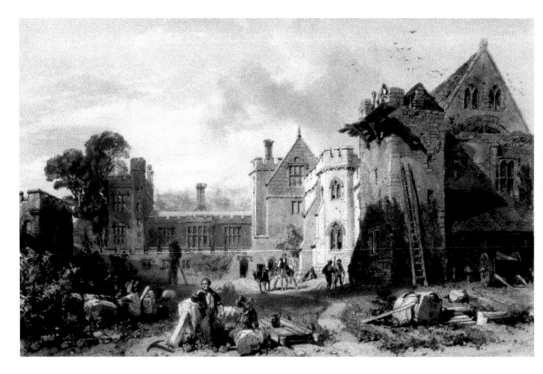

Following its de-fortification, as it were, Penshurst became one of the grandest houses in Kent. Notable additions were made to the medieval portions, in Tudor and later centuries, but if you look carefully you can still discern its origins as a castle. The gardens are partly formal, in Tudor style, and partly parkland, as they would have been in the Middle Ages. All in all, a perfect place to study the etymology of castles, especially when seen adjacent to its attendant village creating a complete and picturesque scene.

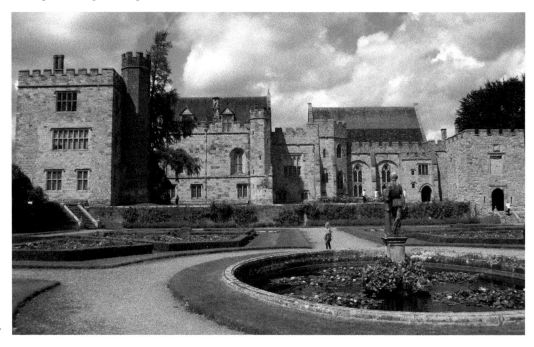

Queenborough Castle

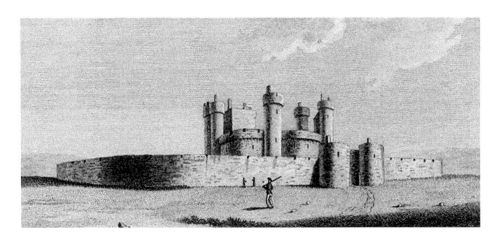

Most people are surprised that Queenborough, on the Isle of Sheppey, ever had a castle, for nothing of it remains today above ground. It was indeed a remarkable structure, built by Edward III in 1361–8 to protect his new town of Queenborough and the wool trade carried out from there. Ironically, although nothing survives of the castle, we know exactly what it looked like because of the wealth of documentary evidence that survives. It was circular and perfectly concentric with a central rotunda and evenly spaced towers. The castle was destroyed by Parliament following the Civil War, although parts were still standing as late as 1807, but sadly all has now gone. Few castles can have been so thoroughly rooted out to leave no trace today. This aerial view, however, although not of particularly high quality, still shows the outline of the castle, discernible in the grass.

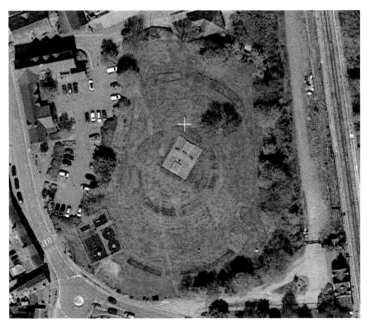

Reculver Roman Fort

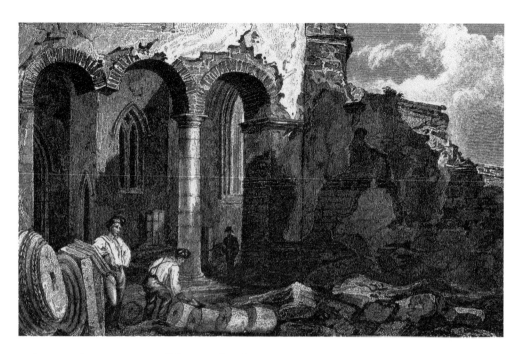

Today, Reculver is more well known for the twin towers of a Norman church that stands precariously close to the cliff edge. The towers are all that remain of a church originally founded in around 669 by Egbert, King of Kent, when he founded a monastery there. It was rebuilt during the twelfth century, when the towers were added. However, the church stands within the precincts of a Roman fort (Regulbium) built to protect the northern approaches of the Wantsum Channel. Severe cliff erosion caused parts of the church, and half of the fort, to collapse into the sea. The church was finally demolished in 1809, leaving just the towers for use as a beacon to shipping.

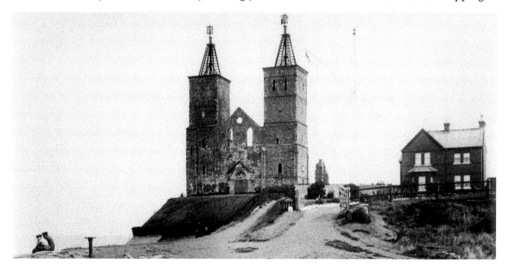

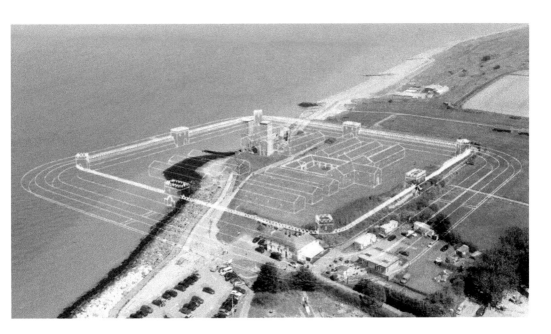

The Roman fort at Reculver (like those at Richborough and Stutfall) is often referred to as a castle and was erected around 210. Originally, it was roughly square, with sides of around 200 yards in length. It was of very simple construction with no protruding towers and had rounded corners. Two sections of wall still stand to a height of around 6 feet, but these are only visible outside the compound. The remarkable reconstruction drawing illustrated here shows what the fort probably looked like in its heyday. The site is now operated as a country park and nature reserve.

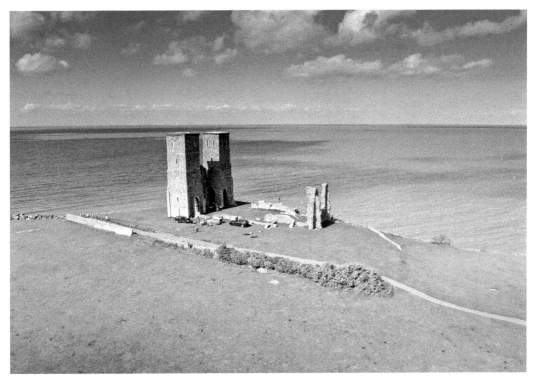

Richborough Roman Fort

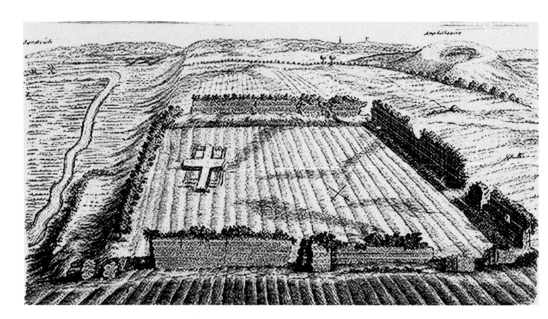

Like its near neighbour Reculver, Richborough has long been known as a castle, though it is not medieval but a Roman fort. It still preserves long stretches of its original walls, in places over 20 feet high, and considerable remains of the earthwork ditches that surrounded it. It was built between 287 and 293 and replaced an earlier timber fort. Alongside was once a substantial Roman town, complete with amphitheatre, sadly all now gone except the massive walls of the fort.

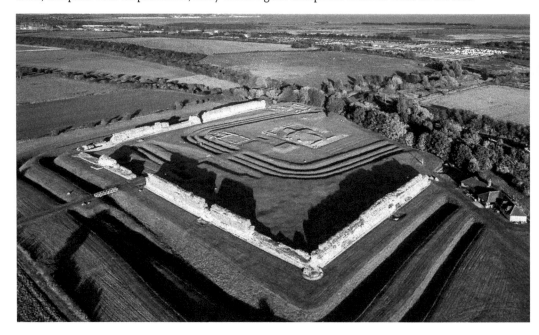

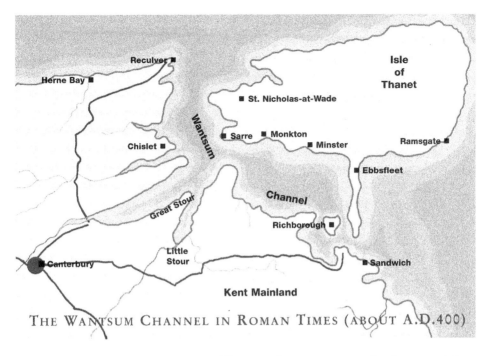

THE WANTSUM CHANNEL IN ROMAN TIMES (ABOUT A.D.400)

In Roman times, and right up to the Middle Ages, Thanet was a true island, separated from mainland Kent by the Wantsum Channel, a wide, shallow, but navigable expanse of water. It provided a quicker and safer passage from London to the Continent. The Romans protected it with a stone fort at either end. Richborough itself once stood on a separate island within the channel. These two maps give an impression of how this part of the coast once looked, compared with today, to give a better understanding of why the two forts were built.

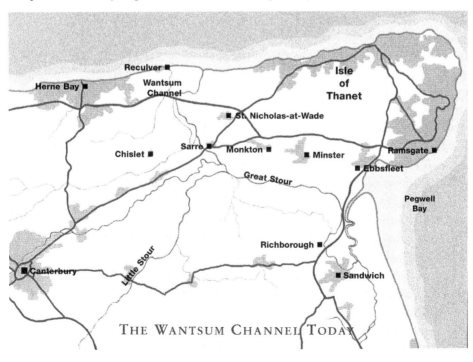

THE WANTSUM CHANNEL TODAY

Rochester Castle

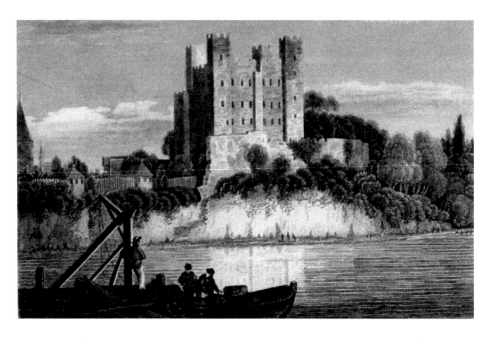

Impressive from every approach, Rochester Castle possesses one of the finest, and original, keeps in Europe. It is also the tallest in Britain standing 113 feet high. A cross-wall inside divides the keep into two halves. The second storey contained the state apartments and here the cross-wall is pierced by four huge Norman arches to create more space and light. The Esplanade at Rochester wasn't constructed until the nineteenth century and originally the waters of the River Medway lapped the base of the castle walls.

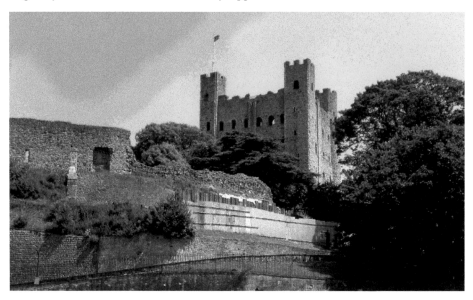

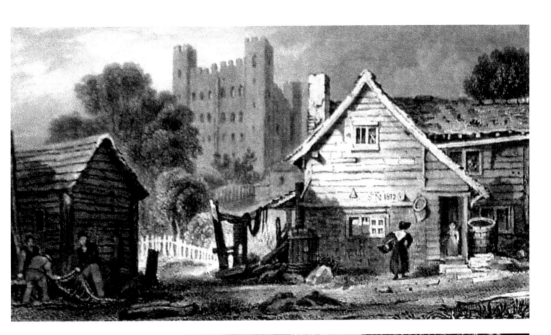

The most remarkable event to take place at the castle was the 1215 siege by King John. Rebellious barons held the castle against the king and John himself conducted the siege, which lasted just seven weeks. Massive siege engines were brought to bear on the castle and a mine was dug beneath the south-east corner of the keep, which succeeded in bringing down that corner of the tower. When the castle was subsequently repaired the south-east corners of the keep and curtain wall were replaced with stronger, semi-circular towers.

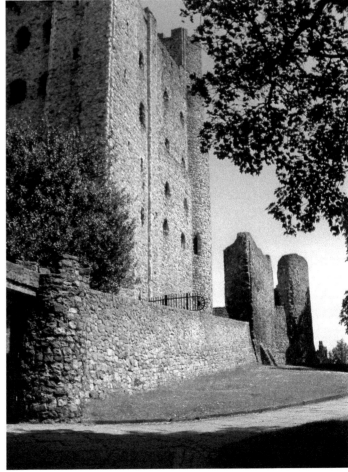

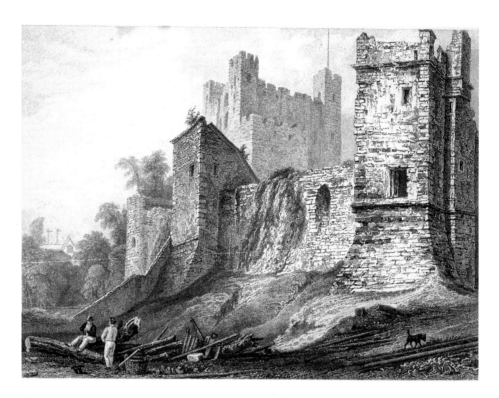

The first castle at Rochester was a timber motte and bailey, built soon after the Conquest, which stood just outside the Roman city walls. The site is now occupied by houses in Boley Hill. This was replaced in stone around 1088 on a site (the present site) just inside the city walls. The keep was added in 1127. The Esplanade at Rochester wasn't constructed until the nineteenth century and originally the waters of the River Medway lapped the base of the castle walls. The prospect on the eastern side of the castle once looked very much different to the present view. A number of buildings were built hard against walls in the moat on the eastern side, all of which have now been swept away.

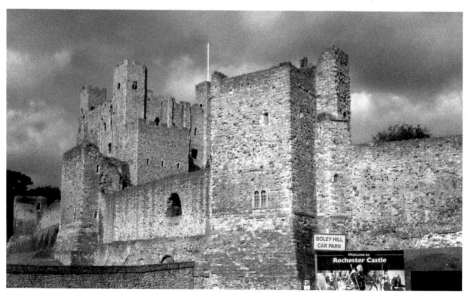

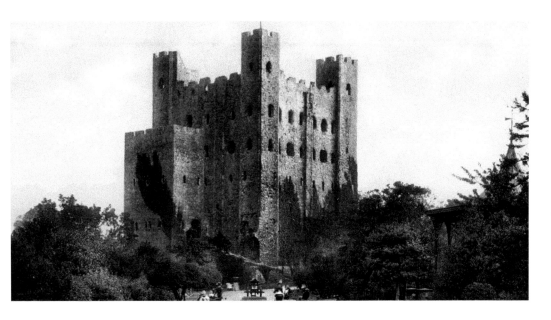

Rochester Castle fell out of use at quite an early date and by Elizabethan times it already stood in ruins, its keep floorless and roofless, and its walls robbed of stone to construct buildings elsewhere in the city. Eventually, it was acquired by Rochester Corporation, who carried out essential repairs to the keep and created a public garden in the bailey, with trees, shrubs and walkways. In more recent times these have also been removed to create the clear, open space we see today. In summer months concerts are held in the castle grounds, providing a unique backdrop and giving the castle a new lease of life.

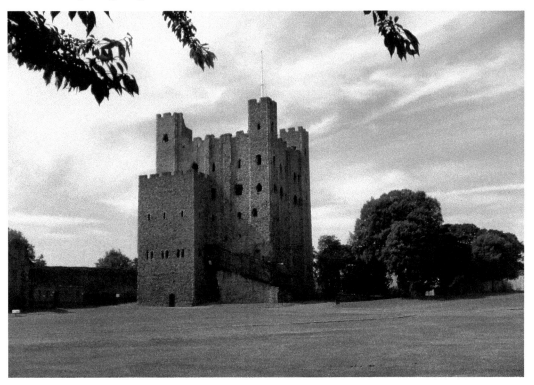

Saltwood Castle

Saltwood is one of the most complete and unspoilt castles in Kent to survive the Middle Ages, in an almost unscathed condition. It stands on a steep hill above Hythe. In medieval times the sea washed the foot of this hill, but land reclamation on the Romney Marsh has left the castle now some miles inland. A Saxon fortress was built on a level platform on top of the hill in 488, which later formed the inner bailey of the Norman castle that followed.

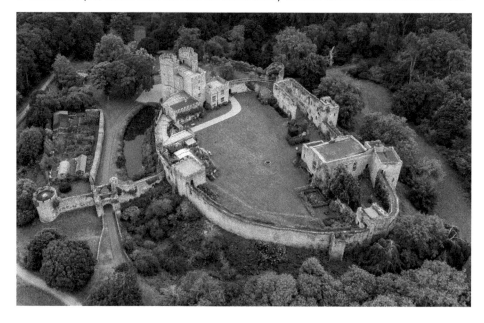

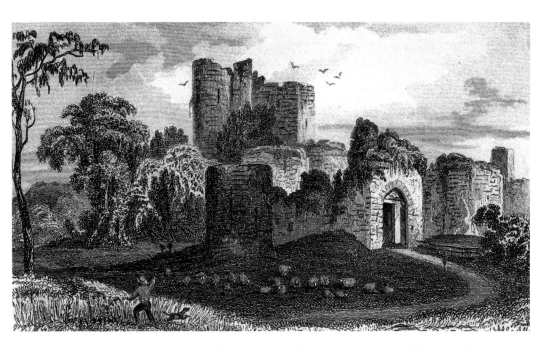

As long ago as 1026 the manor of Saltwood became the property of the Archbishops of Canterbury, when King Canute handed it over to the church, an act that was to have dire consequences nearly 150 years later. Saltwood Castle was at the centre of the squabble between Henry II and Thomas Becket and it was there that the four knights met to plot the archbishop's murder. Despite this, the castle remained in church hands and has survived the centuries in remarkably good condition. I must confess, it is perhaps my favourite castle of all those I have visited over the years.

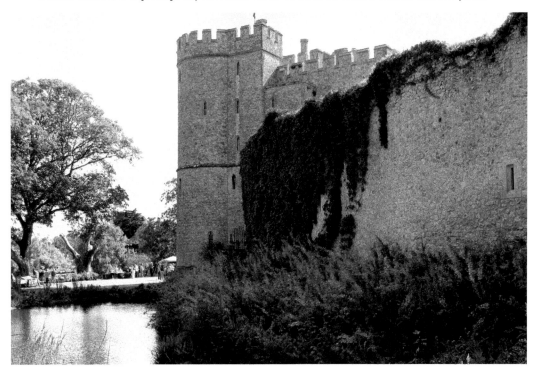

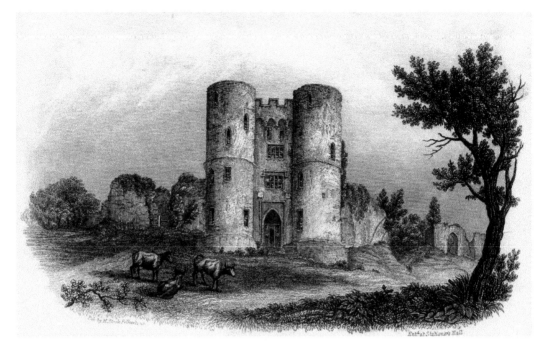

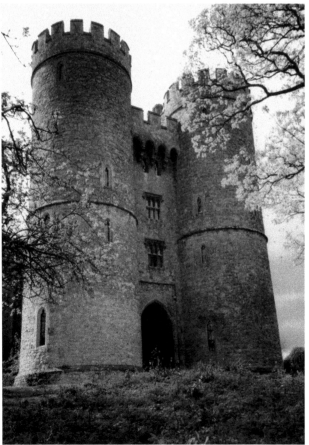

Prior to Becket's assassination, Henry II installed Sir Ranulf de Broc as castellan at Saltwood and he is believed to have built a keep there. In the 1380s Archbishop William Courtenay built the magnificent inner gatehouse at the castle, incorporating parts of this keep. The gatehouse bears a striking resemblance to the West Gate at Canterbury, also built by Courtenay. Lady Conway acquired the castle in the 1930s and carried out much restoration work, making the gatehouse once more a habitable home. Lord Clark (the historian) purchased the castle on Lady Conway's death and his family still live in and care for the castle today, striking the perfect balance between romantic ruin and family home.

Sandgate Castle

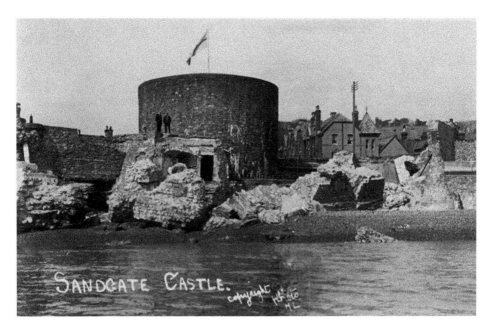

Sandgate Castle is another of the fortifications erected around the Kent coast to protect England from invasion. It is quite unlike the others, however, which were circular in plan. At Sandgate the design was roughly triangular, but with elliptical, curved sides. It had an outer and inner chemise, with round towers at each angle of the inner wall and a central, circular tower. In 1806 it was drastically altered and the central tower converted into a Martello tower. The seaward side has also been badly damaged so that few of the original Tudor details remain. In later years it was used as a restaurant and is now privately owned.

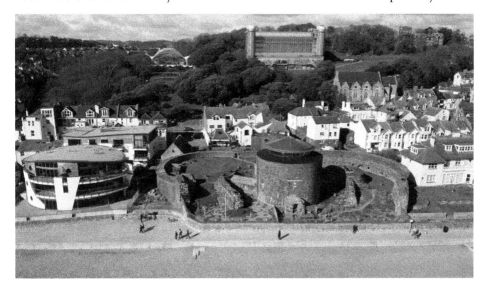

Sandown Castle

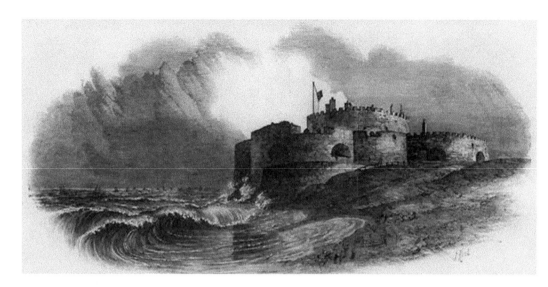

Of the three castles built by Henry VIII to protect the Tudor fleet, Sandown has faired much less favourably than its near neighbours Deal and Walmer. Deal, the central castle, was the largest, with Sandown and Walmer to the north and south, of around equal size. From quite an early date (1785) the sea encroached and overwhelmed the castle at Sandown, although it still remained largely intact until the late nineteenth century (the date of this print). However, with the changing position of the Goodwin Sands causing tidal changes, it became more vulnerable and suffered much damage. It was finally demolished by the Royal Engineers in 1894 because it had become unsafe.

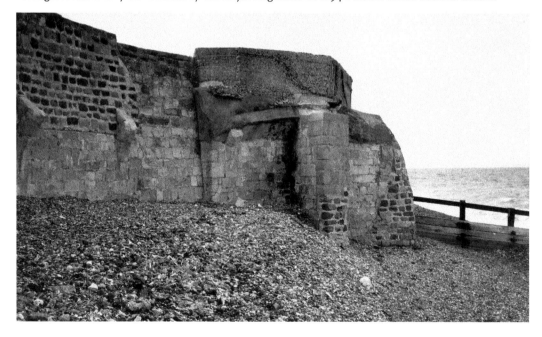

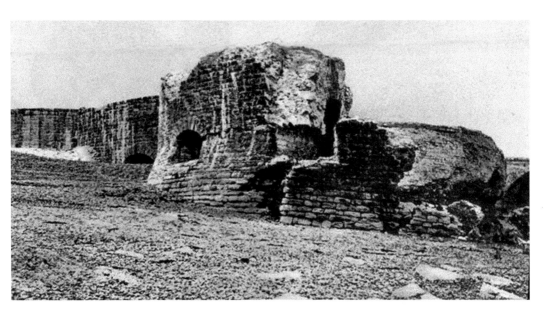

Following the demolition of the castle, much of the stone was used in constructions in the surrounding suburbs of Deal, including parts of the sea wall. A pile of rubble remained on the beach and the inner, curved wall of the entrance bastion. Around forty years ago the local council erected an ornamental memorial on the roadside out of the castle stone, but more recently a local community group have created a much more appropriate, and quite beautiful, memorial garden on the site of this once impressive fortress. A fitting tribute.

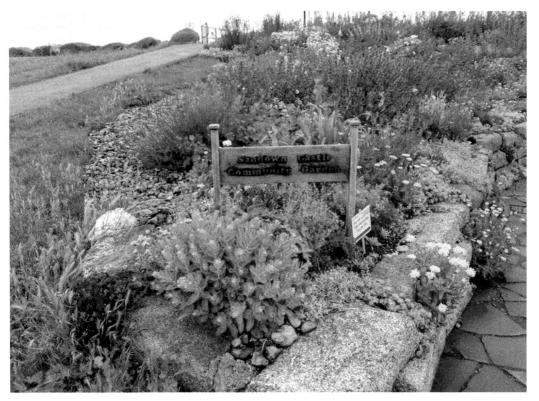

Sandwich Castle

Although a castle is believed to have existed at Sandwich, any traces are probably incorporated into the remains of the town defences, so the two should perhaps be considered as one. The impressive earthworks of these defences still survive, with a pleasant walkway constructed on top, but the only masonry remains are to be seen in two of the original five town gates – the Fisher Gate and the Barbican Gate. The latter still stands guard over the bridge that gave entrance to the medieval town, now somewhat marooned by the traffic all around it. Sandwich recovered from the silting up of its harbour when the Wantsum Channel dried up and the River Stour changed its course by inviting Dutch and Flemish weavers to settle there and it remains as one of the most complete and unspoilt medieval towns in England.

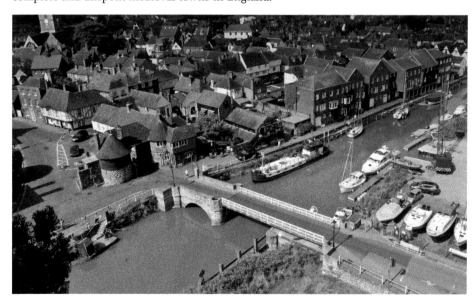

Scotney Castle

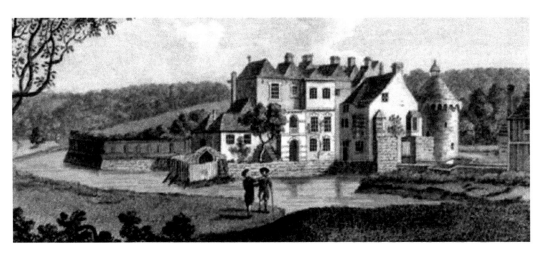

Scotney Castle was built between 1378 and 1380 by Roger de Ashburnham in response to the threat of a French invasion. It was a simple courtyard castle, roughly rhombus shaped, and originally had four corner towers, only one of which survives today. It is also perhaps one of the most photographed castle towers in the country sitting, as it now does, amidst a beautiful landscaped garden. The castle sits on a stone-revetted island in the moat, with the outer barbican located on a separate island, the whole forming a truly magical picture.

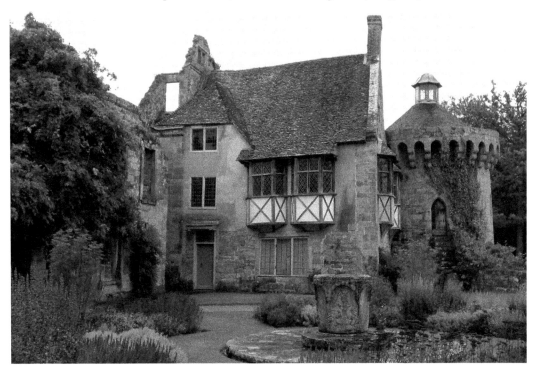

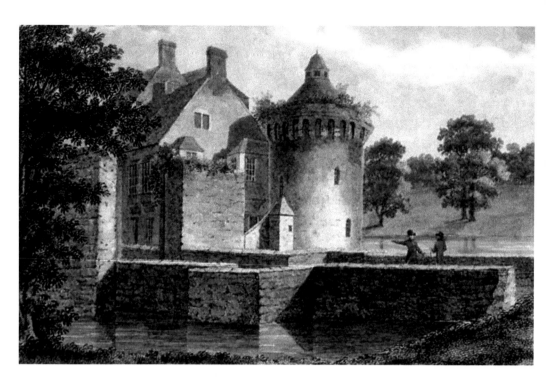

By the mid-sixteenth century the castle appears to have been indefensible and its appearance was softened with the addition of various domestic buildings, especially during the sixteenth to eighteenth centuries. The original hall range was modified and an Elizabethan house built alongside it. In 1836 the then owner, Edward Hussey, decided to build a 'new' castle at Scotney, designed by Anthony Salvin, the renowned medieval revivalist architect. The new 'castle' blends with the older structure rather than attempting to replicate the castle itself and both can now be visited.

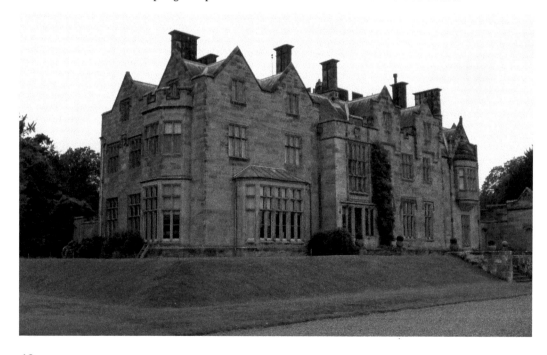

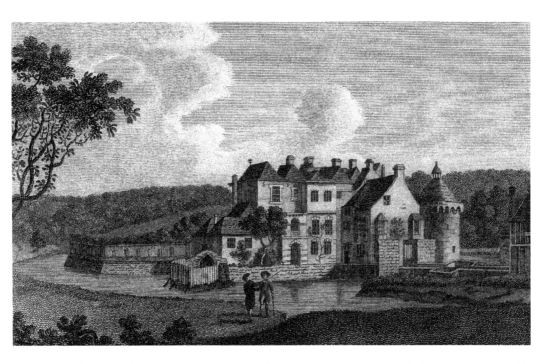

From the start the gardens surrounding the new 'castle' were intended to be unashamedly romantic. Some of the stone used for its construction was taken from the old castle, but most of it was freshly quarried on site. The quarry itself was then incorporated into the garden design. Georgian portions of the house built into the old castle were carefully taken down to reveal the romantic ruins of the Elizabethan and medieval sections and the remaining tower carefully restored. The gardens so created form a perfect backdrop to the castle and are justly famous for their beauty, now cared for by the National Trust.

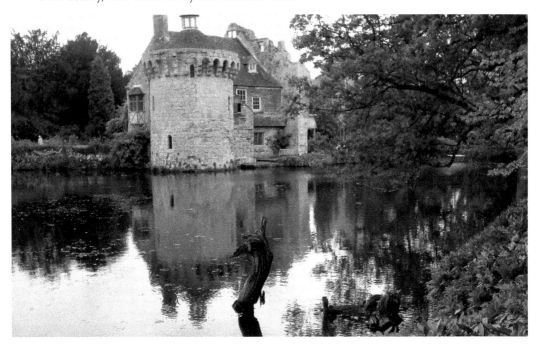

Shurland Castle

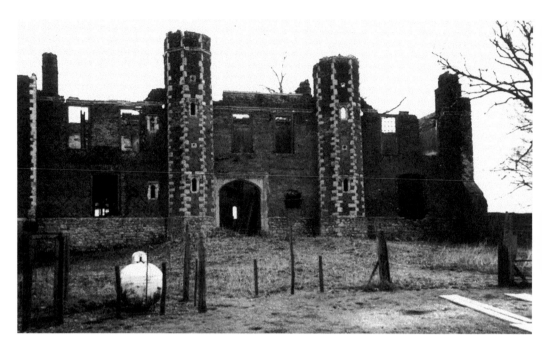

The original castle here, at Eastchurch on the Isle of Sheppey, was built by Sir Geoffrey de Shurland around 1225, on the site of a manor house. The estate later passed to the Cheyney family, who replaced the original castle in the sixteenth century with a fine courtyard house, which he renamed Shurland Hall. He reused material from both the original castle and from Chilham Castle, another of the Cheyney properties, for its construction, along with locally made bricks. By the end of the Tudor period, however, Shurland Hall had already fallen into disrepair.

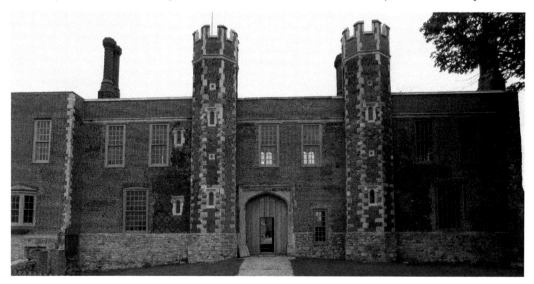

Shurland Hall had once been as large as Sissinghurst Castle, with several courtyards, but all that remains today is the entrance range. For many years this stood in a dilapidated condition with trees poking through the roof and window openings, until it was rescued from total collapse by the Spitalfields Trust just a few years ago. The Trust has a reputation of taking on architecturally important buildings in need of repair – and some much-needed TLC. They carried out a superb restoration programme and Shurland Hall is happily, once again lived in as a private house. A remarkable success story – I applaud them.

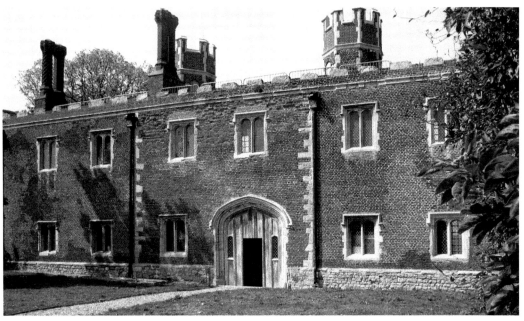

Sissinghurst Castle

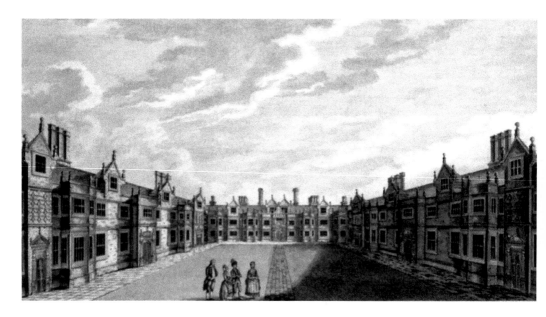

There is no record of a true castle ever having existed at Sissinghurst. The title 'chateau' was given to it by French prisoners of war housed there between 1756 and 1763 and ever since then it has been known as a castle. The original manor house on the site was demolished by its then owner, Thomas Baker, who replaced it with a Tudor, red-brick mansion. The entrance range, with its distinctive central gate tower, was added around 1535.

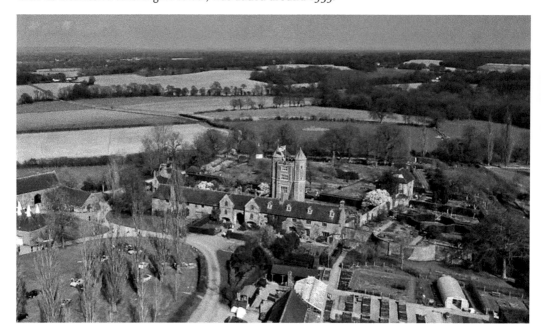

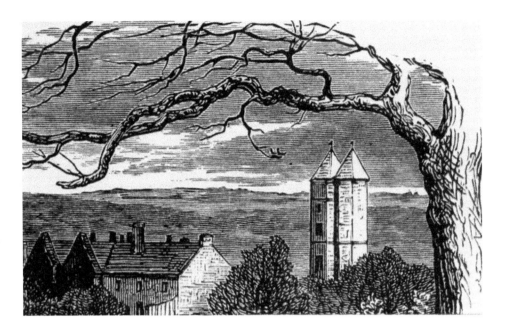

The house was added to over successive generations and is once believed to have contained twelve separate courtyards. Sadly, by the mid-eighteenth century it was no longer habitable and was leased to the government, who used it as a prison. By 1800 the house had become so ruinous that most of it was pulled down, leaving just the entrance range and two small sections, now converted into cottages. The remains were later acquired by V. Sackville-West, who laid out the beautiful gardens for which the castle is more associated today.

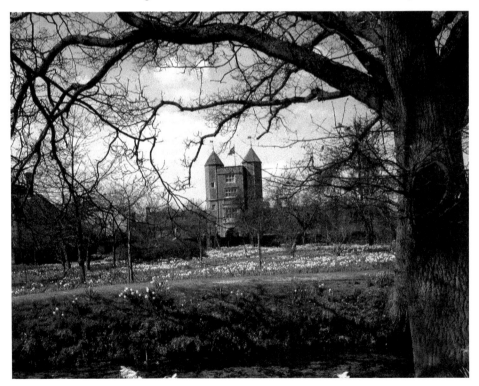

Starkey Castle

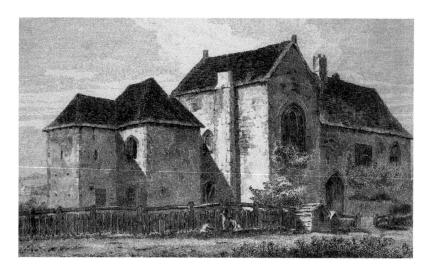

The castle at Starkey, on the outskirts of the village of Wouldham, dates from the fourteenth century, although it did not earn the title of 'castle' until around 1471. What remains is the central hall and residential block of a fortified farmhouse, which still preserves many original features. Any fortifications were probably only slight and no trace remains of them today. During the nineteenth century the hall was divided into two floors and the whole building divided into flats for agricultural workers. For many years it stood empty, but it has now been fully restored and the intervening floors removed, turning it once more into a habitable house. The hall block was once a common feature found at most castles and is a rare survival. The house can be seen from an adjacent footpath approaching across the marshes and water meadows of the River Medway.

Stone Castle

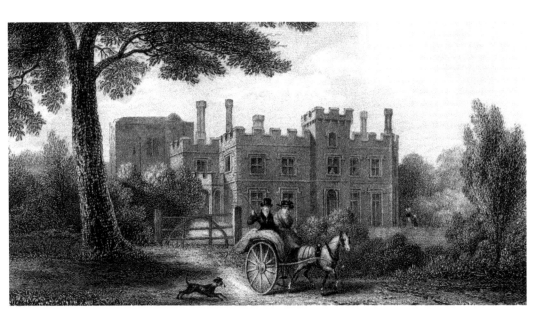

The square tower on the left in these two views is all that remains of the original medieval castle at Stone, near Dartford. Built between 1135 and 1140, mostly using the local flint, it remained in occupation through to Tudor times and was visited by Henry VIII and Anne Boleyn in 1532. It is not known when the castle fell into ruins, but substantial sections of the original structure remained until at least the mid-eighteenth century. The ruins were incorporated into a Gothicised mansion in 1825, which was extended again in 1838, as shown in this old print of that time. It is now used as offices.

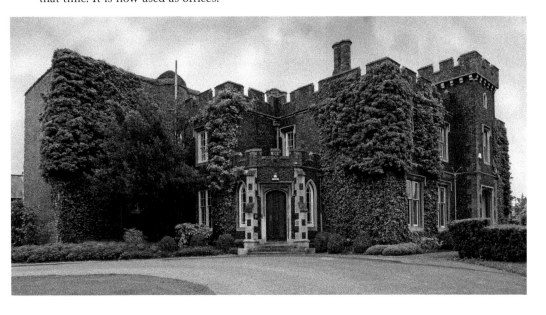

Stutfall Castle

On the cliffs below Lympne Castle can be seen the tumbled remains of a Roman fort, formerly known as Portus Lemanis, but now known as Stutfall Castle. The remains, although scant and severely fractured because of landslips in the area, are still impressive and can be viewed from a nearby public footpath. The fort was originally one of the Roman Forts of the Saxon Shore and stood on level ground overlooking a harbour, but the sea is now some distance away. A watchtower may have stood on the site of Lympne Castle on the clifftop above.

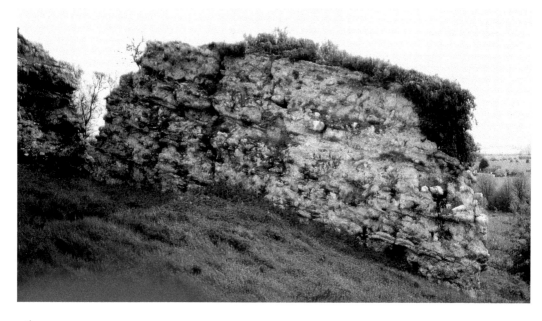

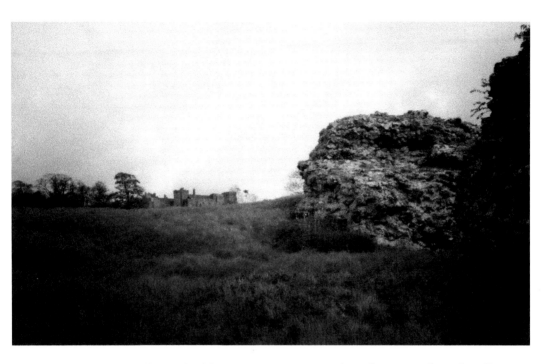

The fort was once of considerable size, measuring around 250 by 200 yards, with walls 20–25 feet high. The romantic ruins cling desperately to the hillside, the solid mass of Roman masonry lying in tumbled heaps like giant recumbent sheep. It is a testament to the quality and workmanship of the builders that huge chunks of the walls have slid down the hillside without breaking, looking out now on the outer paddocks of Port Lympne wildlife park.

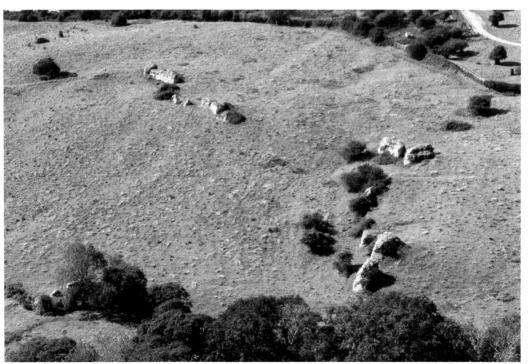

Sutton Valence Castle

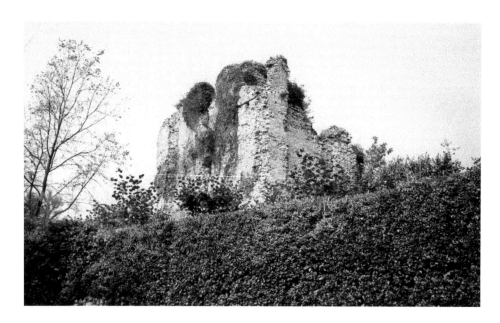

At the time these old photos of Sutton Valence Castle were taken, the ruins stood in a private garden at the far end of the village. They were ivy-clad and surrounded by a rose garden, inaccessible to the public but just visible from the road. The ruins, consisting principally of a small Norman keep, with traces of a forebuilding and other apartments, have in recent years been restored by English Heritage and the site opened up for visitors.

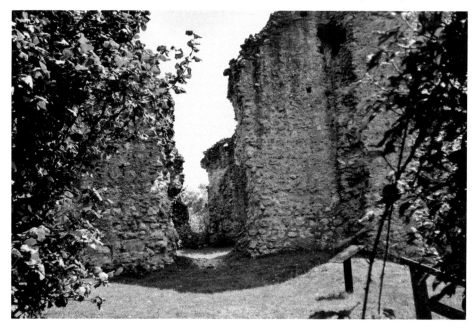

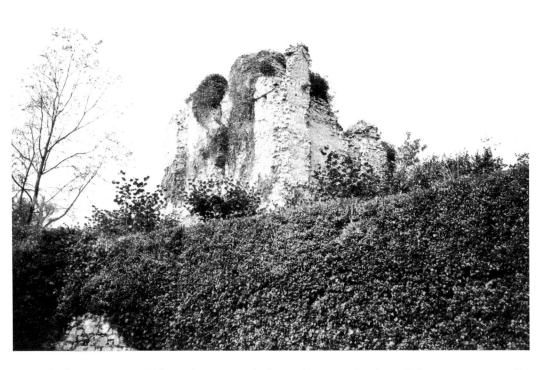

The keep at Sutton Valence is comparatively small, measuring just 38 feet square externally, with walls 8 feet thick. The floor space inside is thus just 22 feet square, providing a large room rather than the usual hall. It stands now to a height of around 30 feet, although it may originally have been twice that height. It is a charming structure, dating probably from the late twelfth century and remarkably similar to St Leonard's Tower at West Malling. For me, it is another success story for Kent castles. When I wrote my first treatise on the subject, I had to battle through undergrowth and thorny roses to get my photos, but now, happily, it is freely accessible!

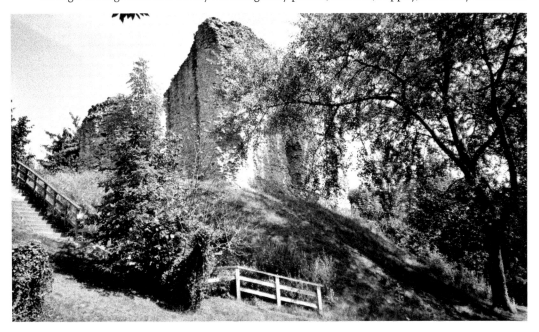

Thurnham Castle

Thurnham Castle stands on the site of a Saxon fortress, known locally as Goddard's Castle, which possibly also occupied the site of a Roman watchtower. The castle was of the motte and bailey type, with the motte and surrounding earthworks cut out of a natural chalk spur on the North Downs, here standing to a height of 650 feet. Although it never developed into a fully fledged castle in the Middle Ages, its position must once have been considered strategically important because of the far-reaching views it commanded across the surrounding countryside.

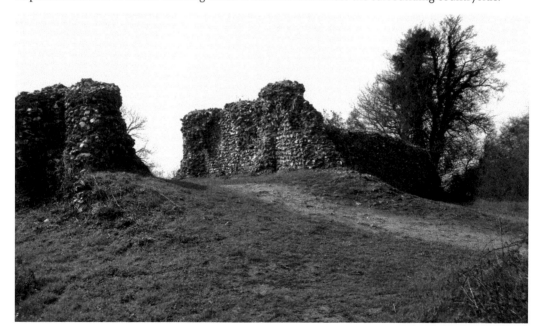

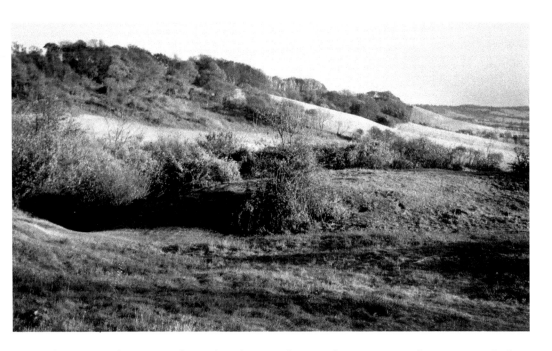

When I carried out research on Thurnham Castle some forty years ago, there was very little to be seen. The earthworks were badly damaged by farming, and masonry remains, such as could be located, were completely overgrown by thorn bushes and ivy. Getting close to them was a painful experience! Happily, Kent County Council, who now manage the site as a country park, have removed this overgrowth and consolidated the masonry to reveal some surprisingly long sections of flint walls. These are mostly from the entrance passage and adjoining walls and are probably contemporary with Eynsford Castle because of the lack of later detail. The earthworks have also been cleared so that it is now possible to ascertain the layout of the entire castle.

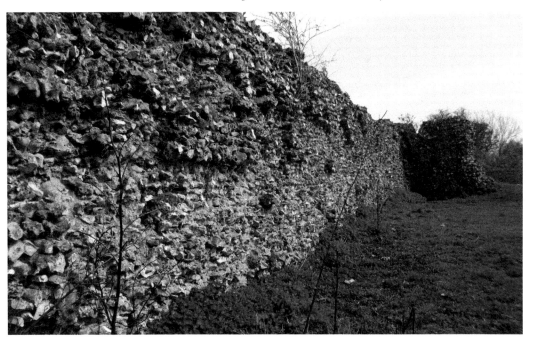

Tonbridge Castle

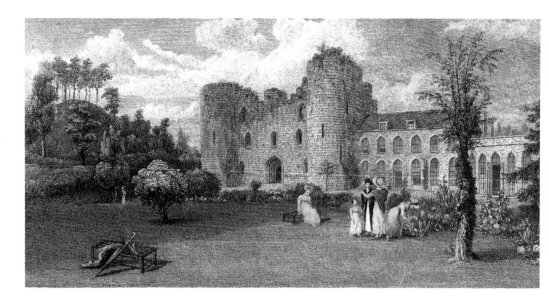

Tonbridge Castle possesses the finest example in Kent of a motte and bailey castle – on a grand scale. The impressive mound, which is possibly of prehistoric date, adapted by the Normans to form the core of their first castle here, is around 275 yards in circumference at the base, around 85 yards at the top and rises to a height of 65 feet above river level. It is crowned by the remains of a shell keep, again one of the finest examples to survive in Kent even though it is much reduced in height. This first castle was built sometime in the late eleventh century. A licence to build a town wall, attached to the castle, was granted in 1259, which became in effect a vast outer bailey, but nothing remains today, except street names that follow its course.

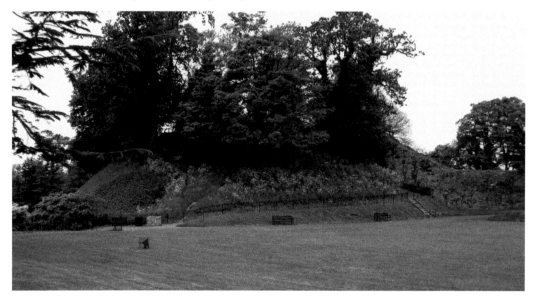

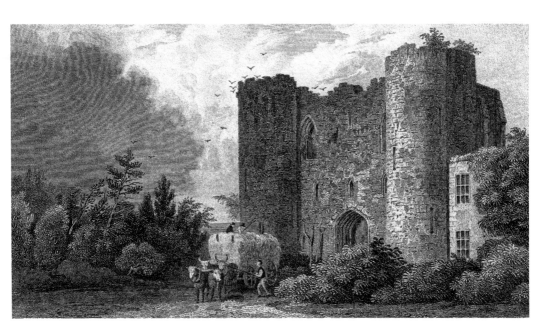

The principal remains to be seen at Tonbridge are the magnificent gatehouse, which had been built by 1275 and may have served as the model for Edward III's later gatehouses at his castles in Wales. It is a remarkable structure, with multiple portcullises and murder holes in the gate passage and individual portcullises protecting every doorway. It still stands to almost its full height. The riverside curtain wall of the castle also survives, with an interesting array of latrine chutes discharging into the river.

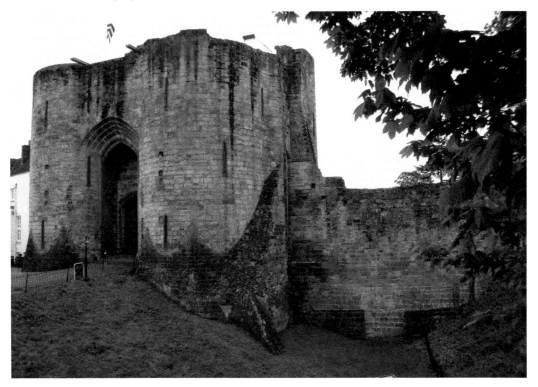

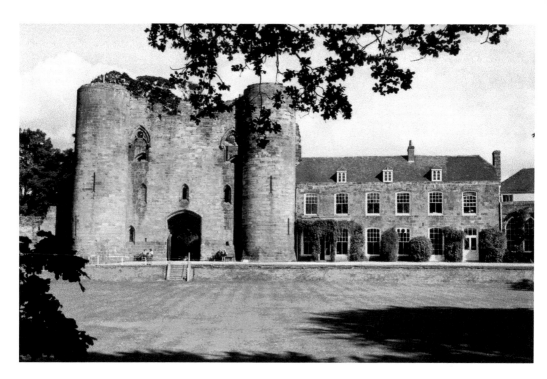

For many years the mighty gatehouse at Tonbridge stood empty and gaunt, robbed of its roof and floors. Its owners, Tonbridge and Malling District Council, recently took the brave decision to reinstate the floors and roof, for which they should be applauded. It is now possible, once more, to experience the rooms and chambers of the castle for the first time in several hundred years, giving the visitor a rare opportunity to see a great medieval building in all its original splendour.

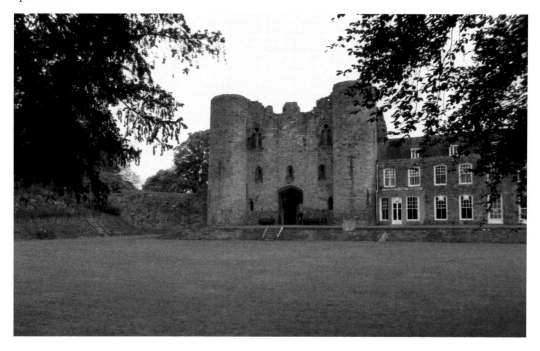

Upnor Castle

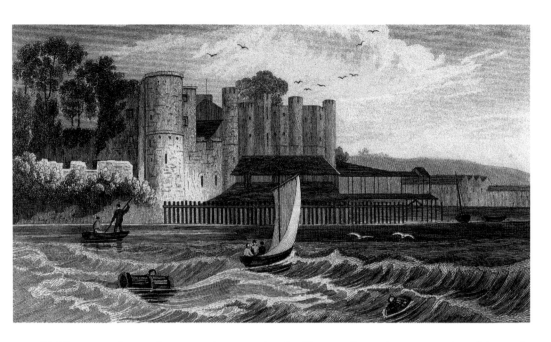

Unlike most other castles, no settlement existed at Upnor prior to the construction of the castle itself. The castle, actually an artillery fort rather than a castle proper, was built by Elizabeth I between 1559 and 1567 expressly for the purpose of defending the infant Chatham Dockyard on the opposite bank of the River Medway. It was partially built from stone plundered from the ruins of Rochester Castle and partly from locally sourced bricks.

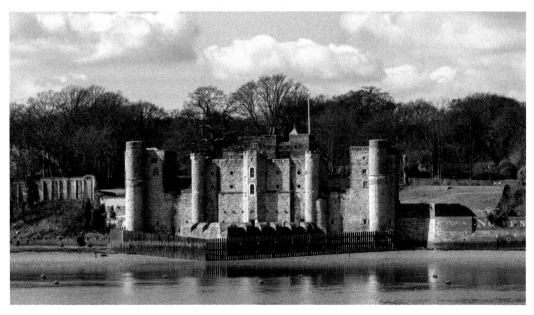

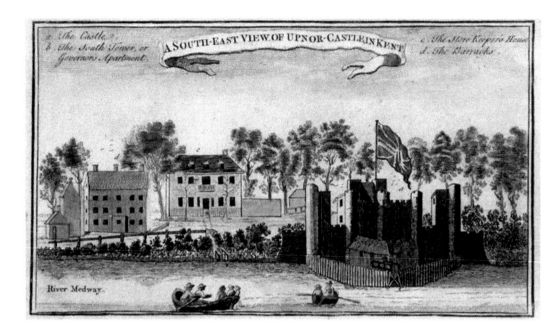

A SOUTH-EAST VIEW OF UPNOR-CASTLE IN KENT

a. The Castle.
b. The South Tower, or Governors Apartment.
c. The Store Keepers House.
d. The Barracks.

River Medway.

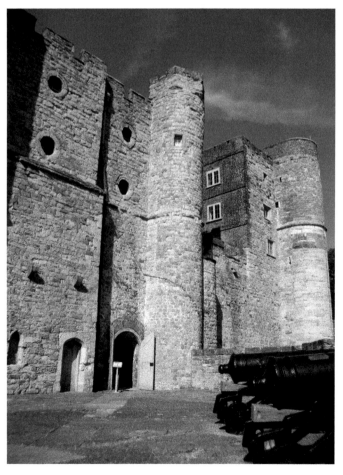

The castle consisted of a central block, surrounded by a courtyard, with a gatehouse facing the landward approach and two towers facing the river. The castle revets the riverbank where a single pointed bastion faced out across the river. The oak door at the entrance is believed to have come originally from Rochester keep. Following the disaster of the Dutch Raid in 1667 the castle was largely relegated to the role of gunpowder store and ordnance laboratory, when the bastion was roofed over. The castle survives today in remarkably good condition.

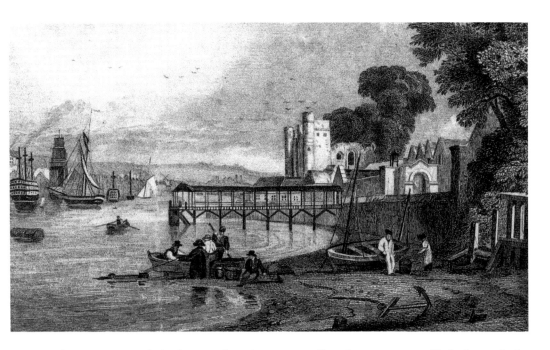

As the importance of Chatham Dockyard grew, a small settlement was established outside the walls, which developed into a small village. The main street running down the hill towards the river contains a number of attractive cottages, with a cobbled roadway resembling more a West Country fishing village than a typical Kentish settlement. In the years before the Second World War the area around the castle even came to be regarded as a small resort, complete with cafes and pleasure gardens, all now gone.

Walmer Castle

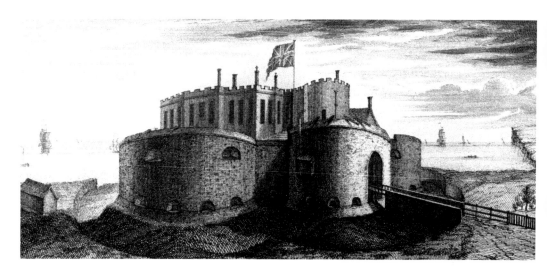

Walmer is another of the three castles built to protect the English fleet moored off the east Kent coast in Tudor times. It was built between 1538 and 1550 and, of the three, survives in probably the best condition. Unlike Deal, which still stands on the shore and Sandown, which was completely overwhelmed by the sea, Walmer lies comfortably inland, surrounded by fine gardens.

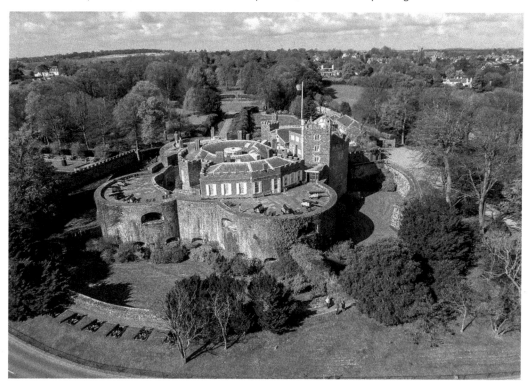

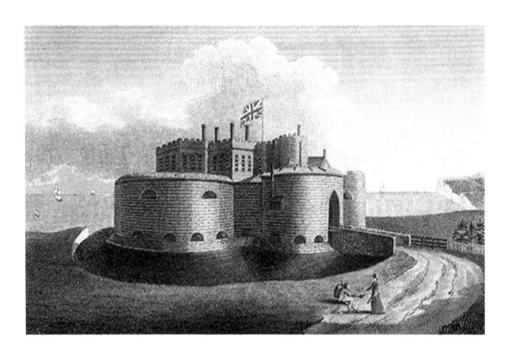

The castle saw virtually no action until the seventeenth-century Civil War. All three castles of the Downs were placed under the guardianship of the Lord Warden of the Cinque Ports and in 1708 Walmer became the official residence of the Lord Warden, a distinction it still holds today, although now it is purely a ceremonial title. Like Deal, the castle was adapted for use as an officers' residence, but unlike Deal the alterations made here were much more tasteful and still survive to form a comfortable home today.

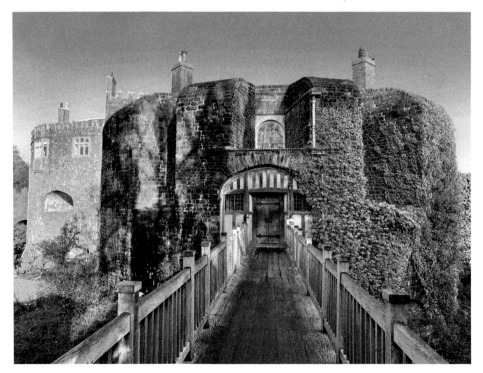

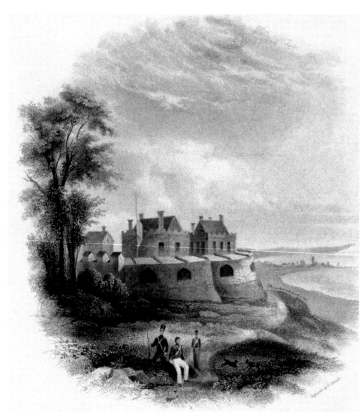

Despite the later residential buildings Walmer still preserves its original layout intact. The dry moat, once a purely defensive feature for enfilading fire, has now been incorporated into the gardens that surround the castle. They were first laid out by William Pitt's niece, Lady Hester Stanhope, while he was Lord Warden, and have been added to successively over the years. When compared to Deal, which has been restored to its original Tudor design, Walmer presents a much softer aspect.

Westenhanger Castle

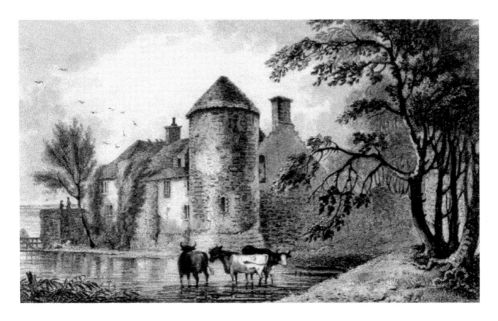

Westenhanger is something of a rare success story in recent times. For many years the castle stood empty and in ruins, sandwiched between Folkestone Racecourse and a railway line. Ivy-clad and romantic it may have been, but it was in a very sad and neglected condition and in real danger of collapse. Fortunately, it was rescued by a local businessman, Graham Forge, who set about restoring the castle.

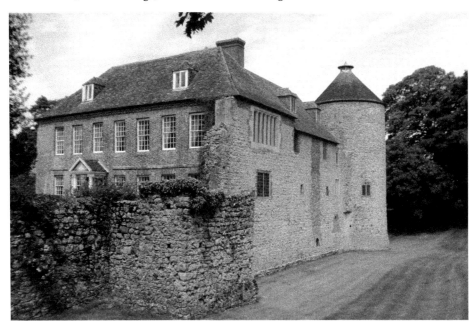

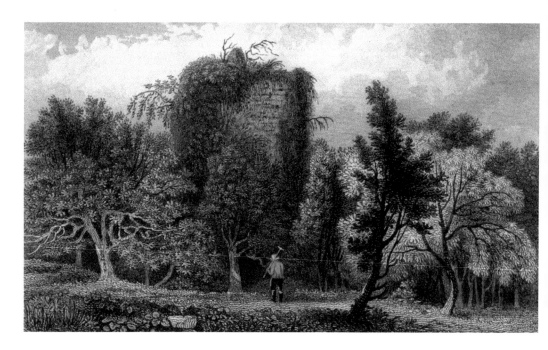

The castle at Westenhanger was of the courtyard type, with towers at each corner and midway along each wall and dates from 1344. Various additions were made during the Tudor period and a Queen Anne-style house was added, probably on the site of the hall. Later in the eighteenth century the present Georgian house replaced this, but sadly it all fell into ruins and a farm occupied the site. It has recently been beautifully restored and is now used as a very attractive wedding venue.

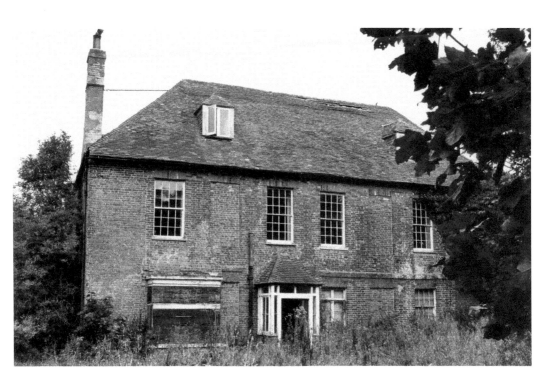

One of the towers at Westenhanger is known as 'Fair Rosamund's Tower' because of its associations with Rosamund Clifford, one of Henry II's mistresses, although the tower itself was not built until the fourteenth century, so it may refer to a previous building on the site. The circular dovecote tower also survives, now fully restored and complete with conical roof. There are also traces of the remaining walls, towers and gatehouse to be seen. Truly, a success story.

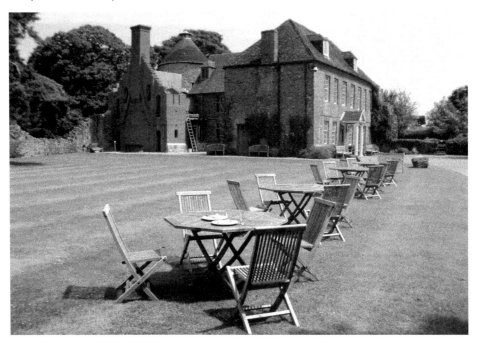

West Malling Castle

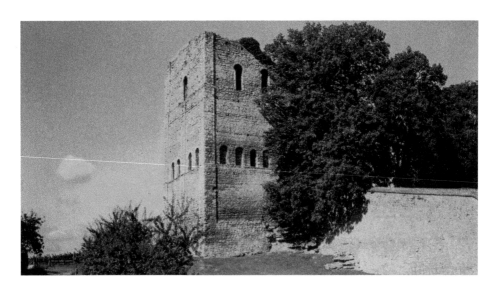

The Norman keep, known as St Leonard's Tower, at West Malling was built around 1070 by Gundulph, Bishop of Rochester. It once stood beside a Norman church of the same name, which has led to a little controversy as to whether it was a defensible keep, or merely an oversized church tower. It probably served both functions, providing a safe refuge for the clergy, but also serving as a bell tower for the church. Gundulph built a similar tower at Rochester, beside the cathedral, which was used as an isolated keep before being superseded by the present keep. Although there is no evidence now of any other buildings associated with the keep at West Malling, isolated keeps were not uncommon and it is certainly too large and ornate to have simply been a church tower. St Leonard's Tower stands to almost its full height of around 60 feet and is one of the most original towers to survive from Norman times.

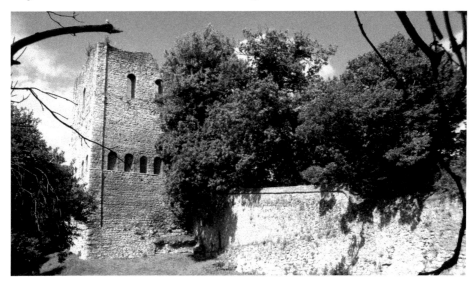